THE PRINCE OF HOMBURG

Heinrich von Kleist

THE PRINCE OF HOMBURG

A new version by
Neil Bartlett with David Bryer

OBERON BOOKS
LONDON

First published in this translation in 2002 by Oberon Books Ltd. (incorporating Absolute Classics)
521 Caledonian Road, London N7 9RH
Tel: 020 7607 3637 / Fax: 020 7607 3629
e-mail: oberon.books@btinternet.com

A catalogue record for this book is available from the British Library.

ISBN: 1 84002 267 1

Cover photograph: *Larry*, 1979, © copyright The Estate of Robert Mapplethorpe.

Printed in Great Britain by Antony Rowe Ltd, Reading.

Contents

Introduction, 9

THE PRINCE OF HOMBURG, 15

A London Original

Hidden away behind a concrete facade on a busy high street, the Lyric has always been one of the most surprising theatres in London. Our work matches the building in its boldness: Kleist and Marivaux alongside collaborations with Improbable Theatre, Frantic Assembly and Told By An Idiot; distinguished contemporary popular music alongside a truly magical annual Christmas show. In the course of a typical season, the Lyric takes pride in creating distinctly different nights out – but each one is stamped with the hallmark of a show at the Lyric: originality.

This year, while all of this work is happening on our stages, we are also taking the building itself into an important new phase of its life. A new purpose-built rehearsal room will finally give Lyric artists the working conditions they deserve; a dedicated education space will enable our acclaimed work with children and young people to reach even further; and a dramatic new glass-fronted entrance sweeping down into a newly created Lyric Square will celebrate the intimate relationship between the theatre and its neighbourhood.

In the meantime, some of the most important things about the Lyric will not be changing: free first nights for local residents, great value tickets, bargain prices every Monday – and an audience as varied as the city we live in. The doors of this theatre, I'm proud to say, are wide open.

Neil Bartlett
Artistic Director
January 2002

Lyric Theatre Hammersmith, King St., London W6 0QL
Tel: 020 8741 0824
Fax: 020 8741 5965
Email: enquiries@lyric.co.uk

The Royal Shakespeare Company

ROYAL
SHAKESPEARE
COMPANY

The Royal Shakespeare Company is one of the world's best known theatre ensembles. The Company is widely regarded as one of the most important interpreters of Shakespeare and other classical dramatists. Today the RSC is at the leading edge of classical theatre, with an international reputation for artistic excellence, accessibility and high-quality live performance.

Our mission at the RSC is to create outstanding theatre that is relevant to our times through the work of Shakespeare, other Renaissance dramatists, European theatre and new plays. We aim to attract and inspire the best artists, and to sustain and delight audiences of all ages throughout the world.

Large-scale productions of the plays of Shakespeare, other classical theatre and Christmas family shows are performed in the Royal Shakespeare Theatre, the Company's main house. The galleried Swan Theatre offers a closer relationship between actors and audience. Productions in the Swan Theatre include work by both classic and contemporary dramatists.

The Company's roots in Stratford-upon-Avon stretch back to the nineteenth century. However, since the 1960s, the RSC's work in Stratford has been complemented by a regular presence in London.

But Stratford and London are only part of the story. Twenty five years of residency in the city of Newcastle-upon-Tyne have forged a strong link between RSC artists and audiences in the North-East. Many of our productions also visit major regional theatres around Britain. And our annual regional tour sets up its own travelling auditorium in community centres, sport halls and schools in towns throughout the UK without access to professional theatre.

While the UK is the Company's home, our audiences are global. The Company regularly plays to enthusiastic audiences in other parts of Europe, across the United States, the Americas, Asia and Australasia. The RSC is proud of its relationships with partnering organisations in other countries, particularly in America. Despite continual change, directors, actors, dramatists and theatre practitioners all continue to collaborate in the creation of the RSC's distinctive and unmistakable approach to theatre.

For further details on the RSC and all RSC productions call 01789 403 440 or visit www.rsc.org.uk.

Patron	Her Majesty the Queen
President	His Royal Highness the Prince of Wales
Deputy-President	Sir Geoffrey Cass
Chairman of the Board	Lord Alexander of Weedon QC
Deputy-Chairman	Lady Sainsbury of Turville
Vice-Chairmen	Charles Flower
	Professor Stanley Wells PhD, DLitt

Direction

Artistic Director	Adrian Noble
Managing Director	Chris Foy
Executive Producer	Lynda Farran
Advisory Direction	John Barton, David Brierley
	Peter Brook, Trevor Nunn
Emeritus Directors	Trevor Nunn, Terry Hands

Associate Directors

Michael Attenborough (Principal Associate Director),
Michael Boyd, Gregory Doran, Steven Pimlott

Heads of Department

Simon Bowler	Head of Engineering Services
John Cannon	Resident Casting Director
Neil Constable	London Manager
Sonja Dosanjh	Company Manager (Stratford)
Liam Fisher-Jones	Development Director
David Fletcher	Director of Finance and Administration
Kate Horton	Director of Marketing
James Langley	Head of Technical Management
Geoff Locker	Technical Director
Caro Mackay	Project Manager
Carol Malcolmson	Planning Administrator
Roger Mortlock	Director of Press and Public Affairs
Jonathan Pope	Project Director, Stratford Redevelopment
Gary Stewart	Stratford Manager
Clare Venables	Director of Education
Andrew Wade	Head of Voice
Stephen Warbeck	Head of Music & Associate Artist
Rachael Whitteridge	Head of Human Resources
Denise Wood	Producer

Introduction

Heinrich von Kleist is that rare creature, a writer who is unlike any other. Sometimes I think his world is very much like Kafka's – but that isn't much help, because Kafka isn't like anyone else, either. There are writers who, because they seem to be writing for a theatre which did not actually exist in their own time, have a singular purity, even ferocity, of vision. I feel this way about Genet, for instance, about Koltes; and about Kleist.

Encountering him, one's first impression is of a compelling strangeness; here is a complete, unknown, other world, recorded in abrupt, obsessive detail. Nowhere is this impression of strangeness more forceful than in *The Prince of Homburg*, with its moonlit opening, its sleepwalking prince, its plot developing ominously from a single ambiguous incident. The strangeness is compounded for a modern audience by the setting; we are somewhere called 'Prussia' in 1810. This is a concrete location, a place of steely military orthodoxy – but also a landscape of the imagination, one that echoes with heights and depths very different to those of the English nineteenth century – the same vistas of exaltation and devastation to be found the music of Beethoven, the architecture of Schinkel, the paintings of Caspar David Friedrich. Yet in the centre of the play is something not strange at all; a young man, alone on stage, shell-shocked by emotion, asking the audience quite directly to share with him an enigma: how it is that a young man – mind and body, present, here, in this room – can be alive tonight, and dead tomorrow morning.

Kleist's contemporaries found him as strange as we do; he is an author who has had to wait for his time. He was born in 1777, in a Europe about to be torn apart by the French Revolution and its aftershocks. The son of a patriotic, high-ranking Prussian family, his short life was a schizophrenic switchback, veering between agonised attempts to conform to the disciplines of military or administrative service and equally agonised rebellion. In addition to his six virtually unprecedented plays, he also wrote eight short stories (each of them a masterpiece). His career as an author and journalist

was both fuelled and sabotaged by a series of what would now be described as nervous breakdowns, and his personal crises strangely echoed the shock and disillusion that followed the sudden defeat of a supposedly invincible Prussia by Napoleon at the battle of Jena in 1806. No wonder his stories and plays are so haunted by sudden disaster, and no wonder colleagues and contemporaries still optimistically devoted to the ideals of the Enlightenment found the violent emotions, reversals and ironies of his work hard to take. On publication, *The Prince of Homburg* was deemed unperformable. Its portrayal of a Prussian officer who collapses centre-stage into grovelling terror at the prospect of his own imminent death earned swift condemnation from the state censor. A few months later, Kleist finally found the death he had sought in active military service. In 1811 he killed himself in a suicide pact with a terminally ill cancer sufferer; this eerily-staged death swiftly brought him the fame his work never had.

The Prince of Homburg

The things we do in the night, in the day seem dreams; sometimes the things we do in the day seem dreams when night comes.

Charles Henri Ford

In the theatrical world which Kleist so cunningly, obsessively constructs, reality is contested. Time and time again, the Prince asks if he is hearing things, seeing things right, if he is awake or dreaming. The known world of army, family and identity becomes the site of a struggle which pits the known against the unknown, the sure against the unsure, the individual against the state, the son against the father, the instinctive against the rational, and especially the nocturnal against the daytime, the lunar against the day-lit. Kleist's Prince is brother to the dangerous, endangered heroines of Bellini's operas: La Sonnambula, a girl who can only act out her love when she is sleepwalking; Norma, in whom the moonlit night inspires not only the most beautiful melody of her century, but also rebellion and infanticide.

In this play, the Prince's swift journey into and through the presence of Death is framed by a mirrored pair of tableaux. The first scene stages a dream sequence which is actually real;

and the last scene a reality which is surely a nightmare. These two scenes are an extraordinary trick of theatre; although the stage picture in both scenes – midnight, a stunned, solitary Prince more out of the world than in it, encircled by all the other characters of the play – is identical, the meaning of the image is utterly different at the end of the play, both for the characters and the audience. Everything looks the same; everything is different. What, then, can be trusted? What can be known?

Perhaps one of the things that makes Kleist's sensibility, his world, seems so oddly modern, is his sense of what we would now call the unconscious. The Prince is a conventional soldier in every respect except one: he sleepwalks. That is, his unconscious mind invades his body. In the opening of the play, he struggles to decipher half-remembered dream images – the glove, the wreath of laurel, a woman whose face he mysteriously (and therefore significantly) cannot remember. Kleist's Kafkaesque plot then takes him on a brutal and cruel journey of what is best described as recognition. He recognises the woman he has fallen in love with, and so learns that we fall in love with people before we meet them; in the centre of the play, he sees a hole in the ground, and suddenly discovers that the grave is waiting for him, not just for everybody else. The very plot of the play is driven by the unconscious, the unspoken, the unspeakable; for all the words, love is unspoken, death is unspoken, and so are the family relations between the central quartet. It is clear that the Prince's dream of wearing the laurel wreath and golden chain can only be achieved through the death of the Elector, and that the Elector's dream of authority can only be realised through the death of the Prince, but even (especially) this central, mutually homicidal struggle between father-figure and son-figure is never spoken. Theatre, for Kleist, is when the unknown is suddenly known, the unspeakable staged.

Another (very attractive) feature of Kleist's modernity is the originality of his women. They surprise. Natalie and the Electress are placed centre-stage in the first scenes as silent icons of Maidenhood and Motherhood respectively, but are promptly shunted offstage as the men go to war. As the screws

of the plot tighten, they take centre-stage again, both emotionally and practically. Their sudden, quiet turns, their shifts from centre to periphery and back again – like the moments when the Electress reveals that she has negotiated for the Prince's life even before he arrives to beg her to do it, or when Natalie suddenly summons her regiment to Fehrbellin – set the harsh machinery of the narrative into sharp relief. As Princess and Wife, they are a crucial counterweight to the masculine world; they embody every stereotype of Romantic imagery, only to dislodge it immediately.

This play is set in a time of war; it opens in the middle of a long, hard, grinding campaign, with the invading enemy close, a crucial battle only hours away, and the possibility of defeat very real. Kleist's portrayal of that war is riven with the blackest of ironies and ambiguities. The play has been staged both as a hymn to the Prussian virtues of obedience and discipline, and as a vitriolic assault on a Father-figure and Fatherland who seek to subdue and dominate all that is visionary. When originally performed in 1828, it was heavily censored, so that the play ended with the Prince restored to his rightful identity as dutiful son of the State. In pre-Second World War Germany, it was again performed as a glorious rite of passage into both manhood and nationhood; the taint of association with Nazi imagery then made the play unperformable until Gerard Phillippe's controversial re-reading of the play for post-war France re-cast the Prince in the image of heroic existentialism. Fifty years later, the play has acquired a new set of resonances; when this translation was being rehearsed in the winter of 2001, heroism, visionary nationalism and the arbitrary death of young men were all being played out and argued over nightly on the evening news. This inevitably affected the way the piece was staged. The historic Prince of Homburg led his misconceived cavalry charge in the seventeenth century; Kleist's telling of his story, full of the bureaucracy, politicking and paperwork of war, is clearly set in the reality of 1810. We kept the costumes of that period, but the lighting and sounds of the production recognised that, in the strange, suspended world that Kleist creates between his dream opening and his nightmare ending, there is a clear

continuity between the Prussian call to arms and our current fears and visions. The Prince's horrified final question – 'Tell me, is this a dream?' – was asked in the present tense.

Staging

Surviving documentation of early productions of Kleist's plays show stages crowded with the grandest of painted nineteenth century Romantic scenery, operatic in its splendour. However, the speed and intensity of his storytelling seems made for an empty stage. This is surely because, like many of his contemporaries', Kleist's attempts to re-invent and re-invigorate the drama were profoundly influenced by Shakespeare. Indeed, this play is full of specific echoes of situation, and even has some near-quotations. Most importantly, Kleist seems to have instinctively understood from Shakespeare that unity can be emotional, rather than geographical; a single stage can hold both direct, intimate scenes and larger-scale images without interruption or pause.

The colours and images of the first production of this translation were also inspired directly by the text. Kleist sets iron-backed discipline against repeated physical motifs of swooning, falling, fainting, kneeling; he obsessively contrasts the vulnerability of flesh with the stern realities of metal and earth; he offsets all the play's poetry of light – a torchlit midnight, the half-light before dawn, the hopeful light of morning itself – with the essential, unforgiving and strangely consoling blackness of the grave. Darkness is in the middle of the play; made concrete.

Translation

This translation is an English version of Kleist's ten-syllable blank verse. I have paid close attention to how much drama is in the syntax; in Kleist, people don't speak about intensely felt emotions or actions; as they speak, they discover them. For instance, often, when the Prince tries to recall a dream or imagine the future, he unselfconsciously slips into the dramatic present tense. I have also respected the fact that in the language of the play, as in the plot, moments of great beauty are brought into collision with the direct and the brutal. I have not tried to smooth away Kleist's sense of vicious black humour; it is one

of the best and most modern things about his theatre. Most of all, I've tried to catch Kleist's suddenness, his ability to surprise. For all their soul-searching, these people have no time to think; from the moment the Elector sees the Prince weaving his laurel wreath, and intuits (correctly) that his fantasies are a challenge, the words, like the events of the play, fall like dominoes, one after another, with all the hallucinatory clarity of a dream.

This translation of the play was made for a particular production; this is the script for that production as it stood on the first day of rehearsal. It incorporates some minor cuts; it also omits some of Kleist's more prescriptive stage directions, since it's my belief that actors work better if they discover when to stand, sit, laugh, cry or be amazed during rehearsals, rather than being instructed so to do by a playwright at the first read-through. The reader should also be aware that this translation was made to be played by a company of 14 actors; Kleist's original cast list specifies additional colonels, officers, corporals, cavalrymen, courtiers, a peasant's wife, pages, ladies-in-waiting, footmen and servants, not to mention 'a crowd of people of all ages'. Underneath this Romantic paraphernalia is a tightly constructed narrative in which all the players know each other, and are all intimately inter-connected as members of the same hierarchy; in the centre of which is an archetypal family; in the centre of which stands the Prince. His drama, insofar as it starts in his dreams, is an intensely private one; but it is always witnessed. From the opening scene, Kleist presents us with a Prince who is watched, who is scrutinised. This translation was enormously influenced by the fact that it was made to be performed in two theatres where that scrutiny can be very close – the Swan in Stratford and the Lyric in Hammersmith – and where the Prince could talk very directly to the audience when he chose.

My thanks to my colleagues in Hammersmith and Stratford, and especially to David Bryer, who guided me word by word through the original German text with both scholarly rigour and uncommon patience.

Neil Bartlett,
Lyric Hammersmith

Characters

FRIEDRICH WILHELM, the ELECTOR of Brandenberg

ELIZABETH, the ELECTRESS, his wife

PRINCESS NATALIE of Orange, their niece and foster daughter, Commander in Chief of Dragoons.

COUNT HEINRICH VON HOHENZOLLERN, of the Royal Staff

MEMBERS OF STAFF of the Royal Household

FIELD MARSHALL DÖRFLING

COLONEL PRINCE FRIEDRICH ARTHUR VON HESSEN-HOMBURG, Commander in Chief of Cavalry

COLONEL KOTTWITZ, Commanding Officer of the Princess' of Orange Dragoons

COUNT TRUCHSS, Colonel of Infantry

CAVALRY CAPTAIN VON DER GOLZ

CAVALRY CAPTAIN GEORG VON SPARREN

CAPTAIN STRANZ

CAPTAIN SIEGFRIED VON MÖRNER

CAPTAIN COUNT REUSS

A PEASANT living near the village of Hackelwitz

Setting

Prussia, during a campaign against the invading Swedish army. Fehrbellin; the Castle, campaign headquarters; then the battlefield at Fehrbellin; then Berlin; then Fehrbellin again.

Time

The action begins just before midnight. The battle is fought early the next morning; the Prince is imprisoned that same day. Forty-eight hours separate the end of Act Two and the start of Act Three. The rest of the play takes place in one night.

Note

The symbol | has been used in the published text to indicate the point of interruption by the following character.

This translation of *Prinz Friedrich von Homburg* by Heinrich von Kleist was first performed at the Swan Theatre, Stratford, on 24 January 2002, and then at the Lyric Theatre, Hammersmith, on 22 February 2002, in a co-production between the Lyric and the Royal Shakespeare Company, with the following cast:

TRUCHSS, Peter Bygott

FRANZ, Andrew Fallaize

THE ELECTRESS, Lynn Farleigh

STRANZ, Matthew Flynn

THE PRINCE OF HOMBURG, Dan Fredenburgh

GOLZ, Derek Hutchinson

HOHENZOLLERN, Will Keen

THE ELECTOR, James Laurenson

PRINCESS NATALIE, Tanya Moodie

SPARREN, Peter Moreton

MÖRNER, Guy Oliver-Watts

KOTTWITZ, Fred Pearson

DÖRFLING, Brian Poyser

REUSS, Crispin Redman

Director, Neil Bartlett

Designer, Rae Smith

Lighting Designer, Paule Constable

Sound Designer, Nick Manning

Movement Director, Leah Hausmann

Casting Director, Siobhan Bracke

Company Voice Work, Andrew Wade and Neil Swain

Production Managers, Stuart Gibbons and Fergus Gillies

Costume Supervisor, Brenda Murphy

Stage Manager, Suzi Blakey

Deputy Stage Manager, Heidi Lennard

Assistant Stage Manager, Rebecca Fifield

ACT ONE

Scene 1

Fehrbellin. A garden, laid out in the old French style. In the background, the Castle, from which a ramp descends.

It is night. The PRINCE OF HOMBURG sits, his shirt open and his head bare, half awake, half asleep, weaving a wreath.

The ELECTOR, with his wife, the ELECTRESS, the PRINCESS NATALIE, Count von HOHENZOLLERN, Captain von der GOLZ, Captain STRANZ and others come quietly out of the Castle and look down at him over the balustrade of the ramp.

Pages with torches.

Hohenzollern
The Prince of Homburg.
Having spent the last three weeks harrying
The Swedish army with his cavalry,
And only reappearing here, at head-
Quarters in Fehrbellin, today, breathless,
His orders were that he should spend no more
Than three hours re-provisioning his men
Before promptly resuming the pursuit
Of the retreating Swedes to Hackelberg;
They were quite clear. He briefed his squadron-leaders
To move out at ten o'clock exactly,
And then threw himself down like a tired dog
To snatch at least some rest before dawn comes
And the battle we're all waiting for starts.
And now – ten o'clock has struck, and past.
The cavalry are all up and mounted
And trampling the turf to mud by the gate,
And who's missing? Who – ? The Prince of Homburg.
Their Colonel. They hunt for him with torches,
Lanterns, candles – and when they find him – he's – ?
(He takes a torch from a page.)

Here; look, here, in the garden...sleepwalking.
Incredible, I know, but there he is;
Seduced by moonlight; asleep, but busy –
Busy weaving himself the wreath of Fame
He dreams Posterity will crown him with.

Elector
What?

Hohenzollern
But it's true. Look, down there. On the bench.
(*He shines the torch down on him.*)

Elector
Asleep? But he can't be.

Hohenzollern
Oh, fast asleep.
Just say his name out loud, and down he'll go.
(*Pause.*)

Electress
This young man is ill.

Natalie
He needs a doctor –

Electress
He needs help, certainly, not ridicule.

Hohenzollern
(*Handing the torch back.*)
He's quite well, ladies...as well as I am!
I'm sure the Swedes will find out just how well
When they meet him in the field tomorrow.
This is just – trust me, I know what he's like –
A minor, temporary disturbance.

Elector
Is it? I thought you'd made this whole thing up.
I want to take a closer look at him.
(*They descend.*)

Stranz

Careful with those lights!

Hohenzollern

It's alright, leave them –
You could send this entire place up in flames,
And he would no more be aware of it
Than would that diamond, on his finger.

(*They surround him; Pages light him.*)

Elector

What sort of leaves is he using? Willow?

Hohenzollern

Laurel; he's been looking at old portraits
In the military academy.

Elector

Where did he find that in our sandy soil?

Hohenzollern

God knows...

Stranz

Possibly the lower garden –
They grow several foreign things back there.

Elector

A mystery. And yet, I'm sure, I know
What is so disturbing this young fool's mind.

Hohenzollern

Oh...that! Tomorrow morning's outcome, sir.
He is imagining astronomers
Christ'ning galaxies in celebration.

(*The PRINCE examines the wreath.*)

Stranz

He's finished it.

Hohenzollern

A shame – a crying shame –
That no one here has a mirror handy.

He'd sidle up and try his wreath on first
This way, then that way, just like a young girl
Trying on a new hat. Something floral.

Elector
My God! I have to see how far he'll go!

> (*The ELECTOR takes the wreath from his hand; he blushes,
> and looks up at him. The ELECTOR winds his chain of
> office through the wreath and hands it to NATALIE; the
> PRINCE stands before her. The ELECTOR leads NATALIE
> back as she holds out the wreath; the PRINCE, reaching out,
> follows her.*)

Homburg
(*Whispering.*)
Natalie. My darling. You're my bride.

Elector
Inside! Quick|ly!

Hohenzollern
What did the | idiot say?

Golz
What did he say?

Homburg
Frederick! My Lord! Father!

Hohenzollern
Damn him! Damn!

Elector
(*Retreating.*)
Open the door for me | now!

Homburg
Mother! Oh, mother!

Hohenzollern
He's crazy! He's –

Electress
Who is he speaking to?

Homburg

(*Snatching at the wreath.*)

Oh! Darling! Don't run away! Natalie!

(*He strips a glove from NATALIE's hand.*)

Hohenzollern

What was that he grabbed?

Golz

The wreath?

Natalie

No, no.

Hohenzollern

(*Opening the door.*) Quickly, get inside sir!
So that this entire scene's wiped from his mind.

Elector

Go back into the dark, Prince of Homburg;
Back into darkness, into black nothing.
When next we meet the struggle will be real!
No battle's won upon the field of dreams.

(*The door slams shut in the PRINCE's face. Pause.*)

Scene 2

For a moment, the PRINCE stands at the door, and looks amazed; then he descends the ramp, holding the hand with the glove to his forehead, quite lost in thought. As soon as he is below, he turns around and looks back up at the door.

Scene 3

HOHENZOLLERN enters below through a latticed gate, followed by a PAGE.

Page

Count, sir; excuse me sir! A message, sir!

Hohenzollern

Sssh! Cricket! Yes? What is it?

Page

I was sent –

Hohenzollern

You'll wake him up with all this chirruping!
Well? What is it?

Page

The Elector sent me.
He does not wish the Prince, when he wakes up,
To hear one word about the little joke
That's just been played on him, is that quite clear?

Hohenzollern

Oh, quite. Go and find a cornfield somewhere
And have a nice deep sleep. I knew that. Go!

(*The PAGE leaves.*)

Scene 4

HOHENZOLLERN places himself some way behind the PRINCE, who is staring fixedly up at the ramp.

Hohenzollern

Arthur!

(*The PRINCE falls.*)

Down he goes; good as a bullet!

(*He moves close to him.*)

Can't wait to hear what story he'll concoct
To account for choosing this precise spot
To lie down and fall fast asleep in.

(*He leans over him.*)

Arthur! Hey! Off with the angels? Hello!
And what brings you here at this time of night?

Homburg

Ah…

Hohenzollern

Honestly… You're too much – the Cavalry –
The squadrons you've been put in command of? –

Have been up and marching for a good hour,
But you; you're stretched out down here, fast asleep.

Homburg

What cavalry squadrons?

Hohenzollern

He's forgotten
He's Colonel in Chief of the Cavalry.

Homburg

(*Standing up.*)

Quickly – where's my –

Hohenzollern

Yes, where is it?

Homburg

There! On the right, Heinz – the right; on the chair!

Hohenzollern

Oh, on the chair –

Homburg

Yes, I put it – I'm sure –

Hohenzollern

(*Looking at him.*)

Then I'm sure the chair is where you'll find it.

Homburg

Whose glove is this?
 (*He is looking at the glove which he is holding.*)

Hohenzollern

How the hell should I know –
(*Aside.*) Damn it! That's what he grabbed from her Highness –
Without anyone seeing him do it – (*Breaking off.*)
Right then, let's be having you; shift!

Homburg

(*Throwing the glove away.*)

Alright! –

Hey, Franz! – that stupid boy was meant to wake me.

Hohenzollern
(*Looking at him.*)
He's finally gone, completely.

Homburg
I say –
I have no idea, Heinrich, where I am.

Hohenzollern
You're in Fehrbellin, you sad, sweet dreamer;
Right down at the bottom of the garden...
That's round below the back of the Castle?

Homburg
(*To himself.*) I wish I was still in the dark. I've been
Wandering around by moonlight again.
(*He gets a grip.*)
Sorry! I know now; do you remember
How hot it was last night in bed – wretched!
I couldn't sleep – so I wandered out here,
And the evening – was so welcoming, so...
Silver-haired, so heavily perfumed, like –
A Persian bride with jasmine in her hair...
I had to lie down with her for a while.
– What time is it?

Hohenzollern
Half past eleven, now.

Homburg
And the squadrons, you said, they've all set off?

Hohenzollern
Yes, of course; ten o'clock, as per orders.
With the Princess' of Orange Regiment
Leading – they're probably already there.

Homburg
Well, that's alright then. Kottwitz knows the plan.
Besides, I would have had to be back here
At two for final briefing anyway:
It's just as well that I stayed put, really.
We should go. The Elector doesn't know?

Hohenzollern

No! He's been tucked up in bed for hours now.

(*They are about to go; the PRINCE stops, turns round, and picks up the glove.*)

Homburg

I had such an amazing dream tonight! –
I saw a palace that was…split open,
Suddenly, shining with gold and silver;
And down a marble staircase came walking
Ev'ry single person I've ever loved,
And they stood right round me in a circle:
The Elector, and the Electress, and –
What's she called?

Hohenzollern

Who?

Homburg

(*He seems to be thinking.*) Her – you know who I mean –
Oh, a dumb person could tell me her name!

Hohenzollern

Countess Platen?

Homburg

No, of course not.

Hohenzollern

La Ramin?

Homburg

No: absolutely not.

Hohenzollern

Bork? Winterfeld?

Homburg

Please; give me some credit! You're so dazzled
By the cheap setting, you can't see the pearl.

Hohenzollern

Well, spit it out then – who's the lucky girl?
What's the lady's name?

Homburg

It doesn't matter,
Really, I'm awake now, and the name's gone –
And anyway, why do you need –

Hohenzollern

Alright!
So; they're standing | right round you –

Homburg

Well, don't interrupt me!
And then, the Elector, looking like God,
Has a wreath of laurel in his right hand:
He holds it up right in front of my face,
And, to inspire me, he takes that gold chain,
From around his neck, winds it through the leaves,
And then, to bestow the crown, he hands it –
Oh my God.

Hohenzollern

To – ?

Homburg

Oh my God.

Hohenzollern

To – tell me!

Homburg

You know it might have been Countess Platen.

Hohenzollern

Platen? Really? Who's just left the country?

Homburg

Platen. Really. Or possibly Ramin.

Hohenzollern

Ah, la Ramin! Yes, her with the red hair –
Or Platen, with those wicked violet eyes.
Now her, her I know you like.

Homburg

Yes, I *like*.

Hohenzollern

And she, you're saying, handed you this wreath?

Homburg

She was like something out of a painting,
Holding it there, with the gold chain shining –
'Fame, presenting Laurels to her Hero' –
My feelings, indescribable; I reach,
Reach out both my hands, to take it from her;
She makes me want to fall down on my knees.
But – like a morning mist up on the hills
When it's lifted by the first breath of wind –
The crowd scatters, retreats up the stairs, goes.
And the staircase, when I step onto it,
Stretches; it's like the stairs up to Heaven;
I grab at people to the left, the right,
Trying to just keep hold of somebody.
I can't! The Castle door's suddenly there –
A dazzling light comes out, swallowing them,
The door's shut in my face, with a bang, slams:
And I'm left standing there, holding a glove,
Snatched from a fleeting figure in a dream,
And now I'm awake, and the glove's still here.

Hohenzollern

Oh, come on, so now you're saying the glove
You've got is hers.

Homburg

Whose?

Hohenzollern

The Countess Platen's.

Homburg

Platen's. Really. Or possibly Ramin's.

Hohenzollern

Oh, what are you like, you and your visions!
I think whoever it was left their glove
Behind as a nocturnal souvenir
Was an entirely flesh and blood creature.

Homburg

You think I – I swear to you –

Hohenzollern

Listen; hell,
What do I care? Ramin, Platen; Platen,
Ramin. We should go. It's nearly midnight;
Why are we standing out here and chatting?

Homburg

You're quite right. We really should be in bed.
Oh, what I did want to ask you, Heinrich:
Are the Electress and that niece of hers
Still here – Natalie, Princess of Orange?

Hohenzollern

Why? – the idiot; I think he –

Homburg

Because –
I was supposed to provide thirty men
To escort them away from the fighting.

Hohenzollern

They left hours ago! Or should have – God knows
The escort's been standing by at the gate
Half the damned night primed and ready to march.
Come on! It's twelve; and before we battle
I, for one, wouldn't mind a little sleep.

(Both go.)

Scene 5

Fehrbellin. A room in the Castle. Shooting can be heard in the distance.

The ELECTRESS and Princess NATALIE, dressed for travel, take a seat at the side. The ELECTOR, Field Marshall DÖRFLING, the PRINCE (with the glove tucked in his jacket), Count TRUCHSS, HOHENZOLLERN, Captains von der GOLZ, von MÖRNER, von SPARREN and STRANZ, Count REUSS and STAFF.

Elector

What's the shooting I can hear? – Is it Götz?

Dörfling

He led the advance guard out yesterday.
We've had his report back, as requested –
The Swedes have an outpost of a thousand
Up here, along the Hackelberg foothills;
But Götz is confident you can proceed.

Elector

Gentlemen: the Field Marshall has the brief;
If you'd all be so kind as to take notes.

(*The Officers gather round DÖRFLING with their notebooks.*)

(*To a COURTIER.*) Is the coach ready for the escort yet?

Courtier

It will be, sir; I'm having it brought round.

Elector

(*Drawing up a chair with the ELECTRESS and NATALIE.*)
You'll have thirty cavalrymen with you;
I'm sending you to Kalkhuhn; the Castle's
On the other side of the Havelstrom,
Where there's not a single Swede to be seen.

Electress

Have they got the ferry running again?

Elector

At Havelberg? Arrangements have been made –
And it'll be light, by the time you're there.
(*Pause.*)
Natalie, you're very quiet, my dear?
Is something wrong?

Natalie

I'm very scared, Uncle.

Elector

You're far safer here with the two of us
Than you were even at your mother's house.
(*Pause.*)

Electress

When, do you think, we'll next see each other?

29

Elector

When God lets me win; as I'm sure he will,
And quite possibly in the next few days.

*(Breakfast is served to the ladies; the PRINCE, pen and notebook
in hand, stares at the ELECTRESS and NATALIE. Field
Marshall DÖRFLING dictates.)*

Dörfling

The plan of battle that his Majesty,
Gentlemen, has devised, is intended
To split up the retreating Swedes, cutting
Them off from their bridgehead on the river.
Colonel Hennings –

Hennings

Sir –

Dörfling

– leading our right wing,
Will attempt to outflank them on the left,
Using this scrubland down here as cover,
Rendezvous-ing with Count Truchss at the bridge –
Count Truchss –

Truchss

Sir –

Dörfling

– *rendezvous*-ing with Count Truchss –
(Stops.)
Who by then will have pulverised Wrangel
With our artillery and seized the bridge –

Truchss

(Writing.) ...with the artillery and seized –

Dörfling

Got that?
(Continues.) Where he will drive the Swedes into the swamps
That lie across here behind their right flank.

Courtier

(Returning.) The carriage is ready for you now, ma'am.

(They rise.)

Dörfling

The Prince of Homburg –

Elector

(Also standing.) And the escort's there?

Courtier

Mounted and waiting down by the gate, sir.

(The Royal Family take their leave of each other.)

Truchss

(Writing.) …behind their right flank…

Dörfling

The Prince of Homburg –

Is the Prince of Homburg here?

Hohenzollern

Arthur!

Homburg

Sir!

Hohenzollern

Concentrate, damn | you.

Homburg

Your orders, Field Marshall.

(He blushes, takes his pen and notebook and writes.)

Dörfling

– to whom his Majesty has entrusted
Overall command of the cavalry,
As at Rathenow – *(He pauses.)*
With no disrespect
To Colonel Kottwitz, who'll be close at hand
To advise him should circumstance require –
Is Kottwitz here?

Golz

No, Gen'ral: as you see,
He's sent me to take down orders for him.

(*The PRINCE is once again looking over at the Ladies.*)

Dörfling
(*Continuing.*) – will be stationed just south of Hackelwitz,
Opposite the enemy's right wing, here,
Well out of range of their artillery –

Golz
...well out of range of their artillery.

(*The ELECTRESS wraps NATALIE's throat in a scarf.
NATALIE wants to put her gloves on; she looks around as if
she's lost something.*)

Elector
What's wrong, Natalie?

Electress
Have you lost something?

Natalie
I don't know – I can't seem to find my glove –

Electress
You're holding it –

Natalie
The right one – it's the left...

Electress
Perhaps you left it up in your bedroom –

Natalie
Could someone – ?

Elector
(*To Staff.*) Quickly!

Natalie
On the mantelpiece –

(*Staff goes.*)

Homburg
(*Aside.*) Oh my God. I must have just not heard right.

(*He takes the glove from his jacket.*)

Dörfling
(*Reading from a paper he holds.*)
Well out of range of their artillery.
(*Continues.*) His Royal Highness will, –

Homburg
This glove she's lost –
(*He looks at the glove, then at NATALIE.*)

Dörfling
Unless he receives specific orders –

Golz
(*Writing.*) ...unless he receives specific orders...

Dörfling
Not move from the post allocated him
Whatever course the battle is taking –

Homburg
– Right, I have to find out, if this is it.
(*He drops the glove, with his handkerchief; then he picks up
the handkerchief, leaving the glove where it can be seen.*)

Dörfling
What is his Highness doing?

Hohenzollern
(*Quietly.*) Arthur?

Homburg
Sir!

Hohenzollern
Have you gone mad?

Homburg
Your orders, Field Marshall?
(*Picking up his pen and notebook again; DÖRFLING looks
askance at him. Pause.*)

Golz
(*Reading from his notes.*)
Not move from the post allocated him.

Dörfling
(*Resuming.*)
Until, pressed by Colonels Hennings and Truchss –

Homburg
(*Quietly, to GOLZ, looking at his notes.*)
Who, Golz? – is this me?

Golz
Of course it's you. Sir.

Homburg
I may not move –

Golz
– Correct –

Dörfling
Have you got that?

Homburg
(*Loud.*) Not move from the post allocated me –
(*He writes.*)

Dörfling
Until, pressed by Colonels Hennings and Truchss –
(*He breaks off.*)
Their left wing goes completely to pieces,
Smashes into their right, their men run like
Lambs to the slaughter into the swamp here,
Where they're trapped in all these dykes and ditches
And we, the plan is, annihilate them.

Elector
Some lights here please! – may I have the pleasure?
(*He leads the ELECTRESS and NATALIE off.*)

Dörfling
At which point, the trumpets will sound the charge.

Electress
(*As some Officers salute.*)
Goodbye, gentlemen. Please, do carry on.
(*DÖRFLING also salutes; the ELECTOR stops suddenly.*)

Elector

Look – there's Natalie's glove; could you? – just there –

Staff

Where?

Elector

Over there, just by his Highness's foot – ?

Homburg

By my feet – ? What?
 Does this belong to you?
(He picks it up and takes it to NATALIE.)

Natalie

Thank you, your Highness.

Homburg

 This is your glove then?

Natalie

It is my glove, yes; I thought I'd lost it.
(She takes it and puts it on.)

Electress

(To the PRINCE as she leaves.)
God bless you, and good luck. We'll meet again –
And under happier circumstances;
See we do.

*(The ELECTOR leaves with the ELECTRESS and
NATALIE; their way is lit for them. The PRINCE stands for
a moment as if struck by lightning; then he turns and strides
triumphantly back to join the group of Officers.)*

Homburg

At which point, trumpets shall sound!

Dörfling

(Returning to his papers.)
At which point the trumpets will sound the charge –
But his Majesty, to prevent any
Likelihood of a premature attack –

(He stops.)

Golz

Likelihood of a premature attack –

Homburg

(*To HOHENZOLLERN, quietly.*)

Heinrich!

Hohenzollern

What is it now? What do you want!

Homburg

Did you see that?

Hohenzollern

No. Shut up, for God's sake.

Dörfling

– Will send out a personal courier
To specific'lly confirm the order –
And please note this – the order to attack.
Until then, no trumpets will be sounded.

(*The PRINCE stands and dreams, lost in himself.*)

Have you got all that?

Golz

(*Writing.*) Until then, trumpets must not be sounded.

Dörfling

Your Royal Highness, have you got that?

Homburg

Sir?

Dörfling

Have you noted that?

Homburg

About the trumpets?

Hohenzollern

Yes, the trumpets, but | not until he has –

Golz

| Not until he has

Confirmed the order –

Homburg

(*Interrupting.*) Yes, I know; not until –
But then, let all the trumpets sound the charge.

(*He writes it down. Pause.*)

Dörfling

Golz, could you note that I'd like to speak with
Kottwitz directly, if that's possible,
Before we engage with the enemy.

Golz

I'll make sure that's arranged. Leave it with me.

(*Pause.*)

Elector

(*Returning.*)
So then, Field Marshall; Colonel; Captains; colleagues;
It's getting light out there. Briefing complete?

Dörfling

Complete, your Majesty; ev'ry officer has
Your strategy noted to the letter.

Elector

(*Picking up his hat and his gloves.*)
And you, Prince of Homburg, try and stay calm.
As you know, you've already cost me two
Battles in this campaign; behave yourself,
And don't deprive me of a third today;
If we lose this one, we may lose the war.
(*To OFFICERS.*) Gentlemen!
(*To his GROOM.*) Franz!

Groom

Sir!

Elector

Bring me round the grey!
I want to be out there before the sun!

(*He goes; all the Officers follow him.*)

Scene 6

Homburg

I've seen you, lifting your veil; seen it shake,
Gently, in the morning breeze – you Monster;
Well, now's the time to mount your wheel, Fortune!
I've already felt you stroking my hair:
Seen you smiling and dropping me hints
As you danced past me with your arms laden:
Well, today, you can run, but I'll catch you;
Catch you on that battlefield and send you
Sprawling at my feet, all your riches spilt:
Even if the Swedes had you manacled
To them with sevenfold chains of iron.

ACT TWO

Scene 1

The battlefield at Fehrbellin.

Colonel KOTTWITZ, Count von HOHENZOLLERN, von der GOLZ, von MÖRNER and STRANZ, offstage.

Kottwitz

(*Off.*) Cavalry, dismount!

Hohenzollern/Golz

(*Off.*) Halt! Halt!

(*KOTTWITZ enters; the others follow.*)

Kottwitz

What a splendid day...as I live and breathe...
The kind of day the good Lord created
For something better than fighting a war –

Golz

Did you catch up with Field Marshall Dörfling?

Kottwitz

No, damn him, what does he think he's doing?
He's had me flying around like a bird;
All the way up the hill to Hackelberg,
Down on the valley road with the rearguard –
The only man I didn't meet was him.

Golz

That's rather unfortunate; I think he had
Something important to discuss with you.

Kottwitz

And where is our Commanding Officer?

Hohenzollern

I'm sure the Prince won't be long.

Kottwitz

Where's he gone?

Hohenzollern
Down into the village. He'll be back soon.

Mörner
I'd heard he had a fall, riding last night.

Hohenzollern
I believe so.

Kottwitz
A fall?

Hohenzollern
(*Turning.*) Nothing serious;
His black shied at a windmill and he slipped.

Stranz
He's here, sir; his Royal Highness the Prince!

Scene 2

Enter the PRINCE, with a black bandage on his left hand.

Kottwitz
Good morning, your fine young Royal Highness;
While you were down in the village, I've had
The cavalry drawn up in the valley;
I trust that plan meets with your approval.

Homburg
Good morning, Kottwitz, morning, gentlemen –
You know I approve whatever you do.

Hohenzollern
What were you doing in the village, Arthur?
You look very serious.

Homburg
 I – went to church.
As we rode past they were ringing the bell
For the start of service, and I felt
I had to go in and kneel down and pray.

Kottwitz
You're a pious youngster, I'll give you that.
'The day that starts in prayer is crowned with peace.'

Homburg

Heinrich, there was just one thing I meant to –
Dörfling's orders at yesterday's briefing,
Which of them were for me specific'lly?

Hohenzollern

I had noticed your mind was wandering.

Homburg

I was – elsewhere. I don't know what was wrong
– I never could get on with dictation.

Hohenzollern

Fortunately not much of it was for you.
Truchss and Hennings are launching the assault,
Using the infantry on the Swedes first,
And you just stand by with the cavalry
Until you get the order to attack.

(*A pause, in which the PRINCE sinks into a dream.*)

Homburg

– It's like a miracle!

Hohenzollern

What is, Arthur?

(*He looks at him. A cannon.*)

Kottwitz

Right then, gentlemen! Saddle up! We're off!
That's Hennings; the battle has started.

(*They climb the hill.*)

Homburg

What is it?

Hohenzollern

It's Colonel Hennings, Arthur,
Moving up unobserved behind Wrangel.
– Come up here, you can see everything.

Golz

He's really moving along the river.

Homburg
That's Hennings way out there on our right wing?

Mörner
Yes, your Highness.

Homburg
Why the hell's he out there?
Yesterday he was out on our left wing.

(*Cannon fire; twelve guns.*)

Kottwitz
Wrangel's opened up on Hennings. Damn him!

Stranz
The Swedes have got themselves well dug in there.

(*Shots nearby.*)

Golz
That's Truchss.

Homburg
Truchss, where?

Kottwitz
Up at the front there – yes:
Moving in to give support to Hennings.

Homburg
Why was Truchss given the centre today?

(*Heavy cannon fire.*)

Golz
Looks as if the village is going up.

Stranz
It's definitely burning –

Mörner
That's the church.
You can see flames right up to the tower.

Golz
Hah! Look, Swedish couriers, left and right –

Mörner

They're moving out!

Kottwitz

Where?

Mörner

Out on the right wing –

Stranz

So they are…three whole regiments of them.

Mörner

And now they're bringing up the cavalry –
They need more cover out on the right there –

Hohenzollern

They'll soon turn tail when they find out what we've
Got waiting for them down in the valley.

(*Rifle fire.*)

Kottwitz

Look at that!

Stranz

Listen –

Mörner

That's our infantry –

Stranz

They're working hand-to-hand in the trenches –

Golz

– God, I've never heard the cannon this loud!

Hohenzollern

Fire! Go on, fire! Rip old Mother Nature's
Guts up! Blast yourselves the graves you'll die in!

(*Pause. Shouts of victory in the distance.*)

Golz

Our Father, which art in Heaven, thank you;
Wrangel's already on the run…

Hohenzollern

He's not! –

Golz

On the right flank – he's clearing out and he's
Taking all his artillery with him!

All

Victory!
 Victory!
 Victory!
 That's it!

Homburg

(*Coming down off the hill.*)

Right Kottwitz, after me!

Kottwitz

Steady on boys.

Homburg

Now! Sound the advance and follow me – now!

Kottwitz

I said, steady.

Homburg

Heaven and bloody Hell!

Kottwitz

His Majesty, at yesterday's briefing,
Was quite clear; we wait until we're ordered.
Golz, read him out his instructions again.

Homburg

Until ordered! Hey, Kottwitz, you're getting slow –
At my age, it's the heart gives the orders.

Kottwitz

Oh, your heart –

Hohenzollern

Please, Arthur –

Kottwitz

 – gives you orders –

Hohenzollern

Take my advice here –

Golz
Listen, Colonel, Sir –

Kottwitz
– does it! Challenging me, are you, young man?
I could ride that nag you prance about on
Into the ground if I had a mind to:
Mount up, gentlemen, and sound the advance!

Golz
(*To KOTTWITZ.*) No, Colonel, under no circumstances!

Mörner
Hennings hasn't got to the river yet –

Golz
Relieve this man of his sword!
 (*STRANZ moves to take the PRINCE's sword.*)

Homburg
 Of my sword?
 (*He pushes him back.*)
You impertinent young idiot;
What's the first Prussian Commandment? Never Touch
Another Officer's Sword. Remember?
 (*He rips his sword and swordbelt off him.*)

Stranz
Your High|ness, –

Homburg
Still chattering away, are we – ?

Hohenzollern
Be quiet! Are you crazy?

Homburg
(*Handing over the sword.*) Corporal!
Take him back to headquarters, under guard.
 (*To KOTTWITZ and the remaining Officers.*)
And now here are your orders, gentlemen;
Whoever won't follow their commander
In the field, is a coward. A coward!
Anyone staying?

Kottwitz
On your head be it. Lead on.

Homburg
On my head be it. And on my command –

(*Exeunt.*)

Scene 3

A room in a village. A COURTIER in boots and spurs enters. A MAN sits at a table working.

Courtier
Hello –
Would you have room here to shelter someone?

Man
We'd be glad to. What sort of a someone?

Courtier
The first lady of the Kingdom. Herself.
Her carriage axle broke, in the village –
But since the news is the battle's over,
She needn't pursue her journey further –

Man
(*Standing.*) The battle's over?

Courtier
 Hadn't you heard yet?
The Swedes are completely beaten, if not
Permanently then at least for a year.
No more burning, no more shooting Prussians.

Scene 4

The ELECTRESS and PRINCESS NATALIE.

Electress
(*In the doorway.*)
Will somebody here please give me their arm!

Natalie

She's so pale! I think she's going to faint.

Electress

Please bring me a chair, I should like to sit.
– Dead, is that what they're saying; dead?

Natalie

 Mother –

Electress

I want to see the man who brought the news.

Scene 5

MÖRNER enters, wounded, two Cavalrymen helping him.

Electress

Well, what is it that you have to tell me?

Mörner

Something that I wish I'd never seen, ma'am.

Electress

– Alright. Say it.

Mörner

 The Elector is gone.

Electress

Tell me exactly how he went missing
– Your words can be like the bolt of lightning
That strikes a weary traveller, lighting
Up his world in one final, purple blaze;
Then, when you've spoken, the night can have me.

Mörner

The Prince of Homburg charged after Wrangel
As soon as he saw he was breaking ranks;
He'd broken two of their lines already,
Cutting them right up while they ran for it;
But he was blocked by one of their trenches;
The fire was so thick, it was like lead rain,
The men went down like wheat in a rainstorm;
He had to call a halt, and regroup.

47

Natalie
(*To the ELECTRESS.*)
You must try and be –

Electress
– Please; please don't, darling.

Mörner
And it was exactly then he appeared,
His Majesty, through the dust, flags flying,
Right there, riding right at the thick of them;
Mounted on his royal white stallion,
With the sun making him blaze, leading us on –
We're all up there on the hill watching him,
Worried of course because he's under fire:
Suddenly down he goes, the horse goes down,
Down in the dust, right in front of our eyes;
His two standard bearers went down with him,
And the colours covered him.

Electress
Go on.
Go on!

Mörner
It was a dreadful thing to see, and when
The Prince sees it, he can't stand the pain, ma'am;
He leads the charge into the Swedes' trenches
Like a mad bear would, gone crazy with rage;
Their ditches and dugouts turn into traps,
And they're overrun, overwhelmed: as they're
Sent scrambling the whole field is left littered
With their cannon – flags, drums, standards, the whole
Swedish machine smashed into pieces, wrecked:
And if that last bridgehead on the river
Hadn't stopped us butchering them, not one,
Not one of them had lived to tell the tale.

Electress
A victory, but one that cost too much.
Somebody give me back the price we paid.
(*She falls in a dead faint.*)

48

Courtier

Well, help me for heaven's sake! She's fainted.

(*NATALIE weeps.*)

Scene 6

The PRINCE enters.

Homburg

Oh my dearest Natalie –

(*He lays her hand on his heart.*)

Natalie

It's true.

Homburg

Oh! If only I could say no.
I would give my own life to bring him back –

Natalie

(*Drying her tears.*)

Have they recovered the body yet?

Homburg

I had business to finish with Wrangel;
But I've sent a squadron out to find him:
I'm sure they'll bring him back before nightfall.

Natalie

Who will keep the Swedish army out now?
Who will keep us safe from our enemies?

Homburg

I will, madam; I'll be your champion;
Stand watch over your threatened throne like a
Guardian angel with a flaming sword.
The Elector hoped to see this country
Freed before the year was out; well, I'll see
To it that his last wish is granted him.

Natalie

My dear cousin. Thank you.

Homburg
O Natalie!
(*He stops for a moment.*)
What thoughts have you had about your future?

Natalie
That. Where do I start, when catastrophe
Has opened the ground up under my feet?
Both my dear Father and my dear Mother
Lie in their graves in Amsterdam; the house
In Dordrecht, where I grew up, is ashes;
My cousin, the Prince of Orange, has his
Own family to save from the Spaniards;
And now my happiness, that fragile plant,
Has had its very last prop smashed away;
Today I was orphaned a second time.

Homburg
Were this not a time for mourning, I'd say:
There's a strong tree here, grow here, round me.

Natalie
My dear, kind, good cousin.

Homburg
Will you? Will you?

Natalie
– And shall I graft myself into its core?

Homburg
What? What was that?

Natalie
We should | go.

Homburg
(*Holding her.*) Into its heart,
Right deep inside its heart, Natalie!
(*He kisses her; she tears herself away.*)
Oh, God, if only he could be here now –
(*NATALIE turns back to the ELECTRESS. A GUARD
enters hastily.*)

Scene 7

Guard
Prince, I don't hardly dare tell you what the
Rumour is that's going round, God I don't!
The Elector's alive.

Homburg
Alive?

Guard
I swear
It's true. Count Sparren just sent this message –

Natalie
Mother – can you hear – ?

Homburg
Who sent a – ?

Guard
Sparren,
The Count von Sparren, he saw him, alive,
In Hackelwitz, with Truchss's infantry.

Homburg
Quick! Run, idiot, I want him here, now!

(*GUARD goes.*)

Scene 8

SPARREN and the GUARD enter.

Electress
Don't dash me to the ground a second time;

Natalie
No –

Electress
Frederick's alive – ?

Natalie
(*Getting her up; with both hands.*)
He's come to raise you up.

Guard

This is the Officer.

Homburg

Count von Sparren, sir.
So you've seen his Majesty safe and sound.
With Truchss's regiment in Hackelwitz.

Sparren

Yes, your Highness, in the churchyard up there –
Giving orders for burying the dead.

Electress

Oh thank God. O Natal|ie –

Natalie

I can't bear it –

(*She buries her face in her aunt's embrace.*)

Homburg

But I saw him go down, didn't I; on his
White horse, cut down, in a hail of bullets?

Sparren

The white horse went down, so did its rider,
But the man riding it wasn't him, sir.

Homburg

Wasn't who? It wasn't his Majesty?
(*NATALIE gets up and stands beside the ELECTRESS.*)
Speak!
Your ev'ry word is worth its weight in gold.

Sparren

His Majesty was riding – we'd warned him –
His white stallion – the great shining beast
Froben bought him last year out in England –
And he was, as he always was on that,
The target of ev'ry enemy gun.
The men in his bodyguard couldn't get
Within at least a hundred feet of him;
Shell-splinters, shot, shrapnel, all flying
Round him like a great, wide, deadly river,
Sweeping ev'rything alive from its path –

But he – was like he was swimming – calmly
Encouraging us to follow him in,
Plunging on upstream, never looking back.

Homburg

It was a terrible thing to witness.

Sparren

Froben, the Master of Horse, had stuck close,
And suddenly I heard him shout at me:
'Damn the beast for being such a shiner! –
Paid a fortune for that coat in London –
Pay it twice to turn him dull as mud now!'
And then, in deadly earnest, he tells him:
'Majesty, he's looking very skittish,
You should let me take the reins for a while.'
– And he gets down off the bay he's riding,
And grabs the Elector's horse's bridle.
He dismounts, smiling – quietly – and says,
'Even with your skills, old man, it'll take
More than a day to teach this one manners.
Take him off behind those hills for me, so
The Swedes can't witness his misbehaviour.'
And he mounts the bay Froben was riding,
And he heads right back to where he's needed.
Froben, he's hardly up on the stall'yon,
Than the bullets cut him and the horse down;
Down into the dust; Loyal Unto Death –
And no one heard him make a single sound.

(*A brief pause.*)

Homburg

He has his reward. If I had ten lives
I couldn't lose them for a nobler end.

Natalie

He was a brave man.

Electress

He was a hero.

Natalie

A lesser man would still deserve our tears.

(*Pause.*)

Homburg

Enough of this. Where's the Elector now?
Still at his headquarters in Hackelwitz?

Sparren

No – he's moved on to Berlin already,
With the rest of the military staff;
They're expecting you to join them up there.

Homburg

In Berlin – is the campaign over then?

Sparren

I'm sorry, I thought you would have known that –
A ceasefire was announced as soon as the
Swedish Ambassador Count Horn arrived;
If I understood Field Marshall Dörfling
Correctly, talks have already started;
Apparently peace may be imminent.

Electress

Dear God, suddenly, ev'rything, brighter.

Homburg

We'd best head for Berlin immediately.
– To speed my journey, do you think you could
Find me a place somewhere in your carriage?
(*He sits down and writes.*)
I must just write two brief lines to Kottwitz,
And then I'll be with you in a moment.

Electress

I'd be very happy to.

Homburg

(*Folds the letter and gives it to the GUARD; then, turning to the
ELECTRESS and gently putting his arm around NATALIE.*)
I have a
Favour I want to ask of you, perhaps
I could tell you about it on the way.

Natalie
(*Freeing herself from him.*)
I can't find my scarf –

Electress
A favour? What kind?
It's round your neck, darling –

Homburg
You've no idea?

Electress
No, none!

Homburg
What? Not even the slightest ink|ling?

Electress
Not even! But today I can't refuse
Anyone a favour, no matter what;
And you, our champion, you least of all.
– Shall we?

Homburg
Do you realise what you have just said?
Have you promised me what I think you have?

Electress
I said, shall we? We'll talk in the carriage.

Homburg
Oh, great Caesar!
My rising star will eclipse even yours.

Scene 9

Berlin. Outside the Castle church; the church is brilliantly illuminated. A peal of bells. Froben's body is carried across and set down on a magnificent catafalque. The ELECTOR, DÖRFLING, TRUCHSS, REUSS, STAFF with dispatches for the ELECTOR. Crowds of people.

Elector
Whoever it was led that cavalry,
Before the Swede's bridges had been taken,
Starting a rout before I ordered it,

He's guilty of a capital offence,
And I want to see that man court-martialled.
– Wasn't it the Prince of Homburg leading?

Truchss

It wasn't, your Majesty.

Elector

Who says so?

Truchss

Some cavalry officers reported
That the Prince – this is before the battle –
Had suffered a fall from his horse, and that
He'd been seen being patched up in a church –
Having injured his head rather badly.

Elector

Well. Today's was a famous victory
And tomorrow I shall thank God for it.
However, its being ten times grander
Would not excuse its being won by chance:
This was by no means my final battle,
And I must, must, have my orders obeyed.
Whoever it was, who led that attack,
He's committed a capital offence,
And I repeat; I want him court-martialled.
Right, gentlemen: let's proceed into church.

Scene 10

Enter the PRINCE, with Swedish flags; KOTTWITZ, von der GOLZ, HOHENZOLLERN, von SPARREN, von MÖRNER.

Dörfling

(When he catches sight of the PRINCE.)
The Prince of Homburg – Truchss, what's going on?

Elector

Where have you come from, Prince?

Homburg

(*Stepping forward.*) From Fehrbellin,
Your Majesty, where I took these for you.

(*Led by the PRINCE, they lay their trophies at the
ELECTOR's feet.*)

Elector

I'd heard you were wounded, rather badly?
Count Truchss?

Homburg

Sorry?

Truchss

Good heavens, I'm amazed –

Homburg

My black slipped, before the battle started;
My hand was patched up by a field doctor,
– But that hardly counts as being wounded.

Elector

So it was you leading the cavalry?

Homburg

(*Looking at him.*)
Me? Of course it was! Don't you believe me?
The proof I did is lying at your feet.

Elector

– Strip him of his sword. He's under arrest.

Dörfling

Who is?

Elector

(*Stepping over the flags.*)
Colonel Kottwitz! Good to see you!

Truchss

(*To himself.*)
Damn!

Kottwitz

I'm at a complete –

Elector
(*Looking at him.*)
– What did you say?
Look at this lot, what a glor'us harvest! –
Swedish Royal Bodyguard, isn't it?

(*Picking up a flag and unfurling it to examine it.*)

Kottwitz
Your Majesty?

Dörfling
Sir –

Elector
Yes, of course it is –
Dates right back to King Gustavus Adolf –
What does the motto say?

Kottwitz
I can't –

Dörfling
Per aspera ad astra.

Elector
Which was hardly the case at Fehrbellin –

(*Pause.*)

Kottwitz
Your Majesty, might | I just say –

Elector
– I beg your pardon?
Have the whole lot – flags, the drums, ev'rything –
Put up in the cathedral tomorrow;
They'll look good at the thanksgiving service.

(*The ELECTOR turns to the couriers, takes the dispatches
from them, opens them and reads.*)

Kottwitz
(*Aside.*) God in heaven this is going too far –

(*The Officers pick the flags up; KOTTWITZ picks up the
PRINCE's, which are left lying there.*)

Reuss
(*Stepping up to the PRINCE.*)
Prince, your sword, if I may.

Hohenzollern
(*Going to his side.*) Gently does it.

Homburg
Am I dreaming? Awake? Alive? Insane?

Golz
I should do what he says, sir, and quietly.

Homburg
A pris'ner – me?

Hohenzollern
That's right.

Golz
You heard what he –

Homburg
And may one ask why?

Hohenzollern
Not at the moment!
As we pointed out to you at the time,
You charged too early: the orders were, Don't
Advance unless you're given the signal.

Homburg
Help me, someone, help! 'Cause I'm going mad!

Golz
(*Interrupting.*) Calm down!

Homburg
So we were defeated, were we?

Hohenzollern
That's not the point! Order must be maintained!

Homburg
Oh – oh, oh, right!

Hohenzollern

(*Walking away from him.*) It won't cost you your neck.

Golz

(*Likewise.*) More than likely you'll be out tomorrow.

(*The ELECTOR collects his papers, and rejoins the Officers.*)

Homburg

(*Having unbuckled his sword.*)

My Uncle Friedrich wants to play Brutus;
He sees himself immortalised in oils,
High on an imperial marble throne:
Swedish flags all draped across the foreground,
And on his desk, the Articles of War.
My god, I will not pose as the Son who,
As the axe falls, looks up in loyal awe.
I was raised a Prussian, in the old school;
I'm used to greatness, and kindness, of heart,
And if he now thinks, at this late juncture,
He can cow me, with this Roman posturing,
I feel for him, and what I feel's contempt.

(*He hands over his sword and leaves.*)

Elector

Take him to Fehrbellin, to headquarters,
And have him court-martialled immediately.

(*He proceeds into the church. The flags follow him and are hung up on the church pillars as he kneels and prays by Froben's body. Funeral music.*)

ACT THREE

Scene 1

Fehrbellin. A prison.

The PRINCE OF HOMBURG. In the background, Guards. Count von HOHENZOLLERN enters.

Homburg
At last! Heinrich! I am so glad you're here.
So, am I still under arrest, or free?

Hohenzollern
For God's sake!

Homburg
What do you mean?

Hohenzollern
 Are you free?
Has he had your sword sent back to you then?

Homburg
To me?

Hohenzollern
Yes.

Homburg
No.

Hohenzollern
So how could you be free?

Homburg
But I thought you – you'd come to – never mind.

Hohenzollern
I've no | news.

Homburg
 Never mind, I said: never mind!
So, he'll be sending someone else with it.
 (*He fetches chairs.*)

Sit down – So, tell me, what's the latest news?
Did the Elector get back from Berlin?

Hohenzollern

(His mind elsewhere.)

Last night.

Homburg

And did the vict'ry thanksgiving
Proceed according to plan? Of course it did.
Was the Elector at the Cathedral?

Hohenzollern

With the Electress and with Natalie –
It was specially lit for the service…
He gave special instructions that you were
To be mentioned from the pulpit by name.

Homburg

Yes, I'd heard. So, that's all the news you've brought?
You don't look terribly happy my friend.

Hohenzollern

Who've you spoken to?

Homburg

Golz, at the castle.

(Pause.)

Hohenzollern

What do you make of your situation,
Arthur, now that it's changed so bizarrely?

Homburg

What do I think? The same as you – as Golz,
As the judges! The Elector's done his duty,
And now he must do what his heart tells him.
'You have erred, my son,' he'll say – solemnly –
He may mention 'Just Deserts'; even 'Death' –
'But I here restore your sword and freedom' –
And round the blade – that won him his battle –
Will hang, possibly, some token medal;
Or if not, that's fine; I don't deserve one.

Hohenzollern

Oh, Arthur. (*Stops.*)

Homburg

Yes?

Hohenzollern

Are you really so sure?

Homburg

Of course I'm sure. I'm a son to him;
I have been ever since I was a boy.
Why on earth are you looking so worried?
Didn't he rejoice in every inch
Of growth I ever made as a young man?
Don't I owe everything I am to him?
Do you really think he'll now trample down
His prize specimen just because it dared
To break into bloom a little early?
I wouldn't expect his worst enemy
To tell me that – much less you, who love him.

Hohenzollern

You've just been tried, Arthur, by court-martial,
And yet you're still sure –

Homburg

Because I've been tried! –
Dear God, things would never have gone this far
Unless he intended to pardon me!
It was when I was standing in the dock,
Standing there, that I knew I was alright.
Would he have hauled me up before that court,
Before that bench of stonyfaced judges
Moaning on like owls at a funeral,
Unless he intended to silence them,
Finally, with one blithe word from on high?
You'll see, my friend; he has gathered storm-clouds
Round my head so that he can play the sun,
Rising to pierce th'encircling gloom. If that's
The way he wants to play it, who am I?

Hohenzollern

But I'd heard the court-martial'd sentenced you?

Homburg

I'd heard that too. To death.

Hohenzollern

You knew.

Homburg

Yes, Golz

Told me, he was there when the verdict came.

Hohenzollern

Well, for God's sake, doesn't that upset you?

Homburg

Me? Not in the least.

Hohenzollern

You're out of your mind!

What makes you so very sure that you're safe?

And what's this certainty of yours based on?

Homburg

My feelings for him.

(*He stands up.*)

Please, don't go on so.

Why should I worry when I don't have to?

(*He has second thoughts and sits down again. Pause.*)

Of course the court has sentenced me to death;

That's what the Law says. That's what the Court's for.

Hohenzollern

But Arthur, apparently –

Homburg

My dear boy –

Hohenzollern

The Field Marshall –

Homburg

Leave it!

Hohenzollern
 Just two words more:
And if they don't get through, I will leave it.

Homburg
You know I've heard it all. Well? What is it?

Hohenzollern
Dörfling – and this is very odd – was sent
Up to inform him of the death sentence;
And he, though clearly he has the power
To grant a pardon, asked for the warrant
To be sent straight to him for signature.

Homburg
Never mind.

Hohenzollern
 Never mind?

Homburg
 For signature?

Hohenzollern
I swear it's true. You have to believe me.

Homburg
– Who told you that?

Hohenzollern
 The Field Marshall himself.

Homburg
When?

Hohenzollern
 Just now.

Homburg
 After he'd been to see him?

Hohenzollern
I was on the staircase when he came out.
He reassured me all was not yet lost,
That tomorrow is another day, but
The look on his face said more than words.

Homburg

He can't – can't be so malevolently
Intentioned towards me. To kill someone,
Someone who has given you a diamond,
Because it has a minute flaw, scarcely
Visible even under a glass – that,
That act would paint Caligula white, fit
The silver wings of holy cherubim
On Sardanapulus, and elevate
Nero and all his family to the
Right hand of God the Father Almighty.

Hohenzollern

You must realise, this is happening.

Homburg

And Dörfling didn't say anything else?

Hohenzollern

What could he say?

Homburg

 Oh God! No hope at all!

Hohenzollern

Have you perhaps ever done anything –
Intentionally, or unconsciously –
That he could have seen as challenging him?

Homburg

Never.

Hohenzollern

 Think about it!

Homburg

 No, not ever!
I worshipped the ground he walked on.

Hohenzollern

 Arthur.
Don't be angry with me, but I doubt that.
Count von Horn, the Swedish Ambassador,
Is here; and his business, or so I'm told,
Rather concerns the Princess of Orange.

Something her Aunt, the Electress, let slip,
Has struck a raw nerve with His Excellency:
'pparently, the young lady's spoken for.
Are you in any way involved in this?

Homburg
What did you just say?

Hohenzollern
 Well, are you? Are you?

Homburg
I am, yes; and that must be what's happened,
That's it; my proposal's been my downfall;
I'm the reason, d'you see, that she's refused;
The Princess has promised herself to me.

Hohenzollern
You stupid, stupid fool! What have you done?
How often have I warned you, as a friend –

Homburg
Heinrich! Help me, please! I'm going under!

Hohenzollern
Yes... There's got to be some way out of this.
Would it be worth your speaking to her Aunt?

Homburg
(*Turning.*) Hey, Guard! Guard!

Guard
 Coming!

Homburg
 Call your Officer!
(*He hastily takes a cloak off the wall.*)

Hohenzollern
(*Helping him into it.*)
This might, handled carefully, just save you.
If the Elector needs her to clinch his
Peace deal with King Karl Gustav of Sweden,
You'll soon see how he makes it up with you;
A few hours from now, you might well be free.

Scene 2

STRANZ enters.

Homburg

Stranz; – I'm under your authority here;
Well, I need leave to go out for an hour
To deal with some very urgent business.

Stranz

Prince, I've no authority over you.
The orders I was given allow you
To come and go of your own free will, sir.

Homburg

How odd – so am I prisoner or not?

Stranz

Sorry, I have to ask you for your word –
As a security.

Hohenzollern

(*As they leave.*) That's alright then;
The Prince's security will be close by.

Homburg

I'm just going up to visit my Aunt,
I'll be back here in less than two minutes.

(*Exeunt.*)

Scene 3

The Electress' room; the ELECTRESS and NATALIE enter.

Electress

Come, daughter, come on! Now is the moment.
His Excellency the Ambassador
Has left the Castle – and taken his Staff;
And the light's still on in your Uncle's room:
So, wrap yourself up, and slip in quietly,
And see what can be done to help your friend.

(*They are about to leave.*)

Scene 4

A member of the Electress' STAFF enters.

Staff
The Prince of Homburg is outside, Madam.

Electress
He's not!

Natalie
　　　　Here?

Electress
Isn't he under arrest?

Staff
He says he absolutely must see you.

Electress
How stupid of him! To break his parole!

Natalie
Maybe he has good reason.

Electress
　　　(*After some reflection.*) Bring him in.

　(*She seats herself in a chair. The PRINCE enters. He sinks
to his knees before her.*)

Scene 5

Electress
What do you want?
Prince! You're a prisoner; why are you here?
Why are you making things worse for yourself?

Homburg
Do you know what they've done to me?

Electress
　　　　　　　　　　I do.
But I am powerless to intervene.

69

Homburg

You wouldn't talk like that, if you had Death
As close to you as I have him to me.
From where I am, you, this young lady, you
Have heavenly powers, powers of Grace,
Ev'ryone around me does – I would kiss
The stableboy who mucks out your horses,
His hands, the least boy, and beg him: Save me!
I'm the only one, in God's whole wide world,
Who's powerless – helpless – can't help himself.

Electress

You sound like someone else. What has happened?

Homburg

Ah! On the way, the way from there to here,
I saw, in the torchlight, open, the grave
Where I will be put tomorrow morning.
You see these eyes, Aunt, that you're looking at,
They want them down in the dark, they want
To drill holes in this chest using bullets.
They've already sold the best window seats
For watching the spectacle, in the Square –
And the man who today's on top of the world,
His future spread out shining below him,
Tomorrow's stinking in a cheap coffin,
And all that the headstone says is: He Was.

Electress

My son! If that is what Heaven decrees,
You must face it quietly and bravely.

Homburg

Oh, but this world of ours is so lovely!
Don't let the black shadows close over me
Before it's time for me to go, please don't.
If I've been bad, he has to punish me,
But it doesn't have to be with bullets –
He could strip me of all of my duties,
Cashier me, if that's what the rulebook says,
Discharge me from the army: Oh my God!

Since I saw my grave, all I want, 's to live,
It doesn't matter what kind of a life.

Electress

Get up, now; stand up! Listen to yourself –

Homburg

I won't, Aunt, not until you've promised me
You'll go to him and beg him for my life.
Remember when my mother was dying,
In Homburg – your childhood friend – and she said,
Look after him, when I no longer can;
You were crying, you knelt down by the bed,
And put your hand over hers, and told her:
He'll be mine, as if he were my own child.
Remember now what you promised her then.
Go, as if you really were my mother,
Tell him – Be merciful!! Set him free!!
Ah, and then come back and tell me: you are!

Electress

My dear boy! I've already done all that.
But nothing I asked for has been granted.

Homburg

I give up all my claims to Happiness.
I renounce – don't forget to tell him this –
My claims on Natalie, here in this heart
All feeling for her is quite extinguished.
She is free, entirely, free as a bird:
Free, to get married, as if I'd not been,
And if it turns out to be to Gustav,
Karl Gustav, the Swede, I'm happy for her!
I'll go to my estate down on the Rhine,
Work on the land there, plough, sow, reap, and then –

Electress

Enough! But before I'll do anything,
You must take yourself back to your prison.

Homburg

You poor girl; you're crying! Today the sun
Lights all your hopes the way to dusty death.

I was the first one you ever felt for
And it's written on your face, clear as day,
You'll never give yourself away again.
How can I, of all people, comfort you?

Natalie
Go on back to your prison cell, hero;
And on the way back, take another look
At the grave they've dug for you. A calm look.
It's no darker, or an inch deeper, than
That you faced a thousand times in battle.
In the meantime I, faithful until death,
Will try and speak to my Uncle for you;
Perhaps I'll be lucky, his heart will soften,
And all your troubles will be at an end.

(Pause.)

Homburg
If you had two wings, one on each shoulder,
I would think you really were an angel.
Did I hear that right? You'll speak to him for me?
– Oh, Hope is as quick as light, when it comes!

Natalie
But if his Highness finds that he can't change
The verdict, then he can't; in which case you,
Because you're brave, will have to bear it bravely:
And just as you won your battles in life,
So you will win your last battle, with Death.

Electress
Go now; the time is right, but it is short.

Homburg
Goodbye. God bless you. Whatever happens,
Make sure the news you bring me back is good!

(Exeunt.)

ACT FOUR

Scene 1

The Elector's room.

The ELECTOR is standing with some papers at a table set with lamps. NATALIE enters by a central doorway, and, at some distance, kneels before him.

Pause.

Elector
(*Putting his papers down.*)

Natalie!

(*He goes to raise her.*)

Natalie

No, don't!

Elector
What is it you want?

Natalie

To kneel in the dust at your feet until
Our cousin Homburg is granted mercy!
I do not want to save him for myself –
Though I do love him, and you know I do –
I do not want to save him for myself –
He can marry whoever he chooses;
All I want is for him to be, Uncle,
Himself; unconfined, unrestrained, alive.
I am begging you, Uncle, Majesty,
Because I know that you will hear my plea.

Elector

Daughter...do you realise what you're saying?
You do know that Homburg was found guilty?

Natalie

Yes, Uncle.

Elector

Well? Was he guilty or not?

Natalie

Oh, it was a childish mistake – one you'd
Forgive before the boy could say 'sorry',
Before you'd even picked him off the ground;
Nobody kicks a fallen child aside;
You would hug him just like his mother would,
And you'd say to him, come on now, don't cry,
You mean much more to me than the Law does.
Wasn't it wanting more glory for you,
That misled him, in the heat of battle,
Into breaking the letter of that Law,
And oh, once broken, didn't our boy then
Despatch his dragon like a grown man should?
To first crown a victor, then behead him,
That's more than the history books require;
That's so high-minded, Uncle, one might say
That it's almost inhuman; and God knows,
You were created the kindest of men.

Elector

My dear girl. Look; a single word from you
Would melt the hardest tyrant's heart; were I one,
I feel absolutely sure it would mine.
But tell me; can I really overturn
A sentence that a court of law has passed?
Think of what the consequences would be.

Natalie

For whom? For you?

Elector

 For me, no! Of course not!
Do you think, young lady, that I matter?
Have you no idea of what we soldiers
Mean when we talk of serving our country?

Natalie

Oh, Sir, is that your concern? The Country!
I'm sure one small outburst of compassion

Won't reduce us to chaos overnight.
This country, of which you are the foundation,
Is a strongly built edifice, Uncle;
It can safely weather much fiercer storms,
I'm sure, than one unauthorised vict'ry;
The rules of war, I'm well aware, must be
Obeyed. But the heart also has its rules.

Elector

Does cousin Homburg think that too?

Natalie

Homburg?

Elector

Does he also think it doesn't matter
If this country's ruled by Law or by whim?

Natalie

He's a very young man.

Elector

And?

Natalie

Oh, Uncle,
The only argument I have is tears.

Elector

What is it, Natalie? What has happened?

Natalie

His mind's a blank, but for one thought: save me.
Staring down a set of rifle barrels
Has got him so scared, stunned, stupid with fear,
Nothing, except staying alive, is left.
He could watch this entire country go down
Flaming in a cloud of fire and brimstone,
And he wouldn't even ask: what's that noise?
– Ah, Sir, what a great heart you have broken.
 (*She turns away and weeps.*)

Elector

But my darling Natalie, surely that's
Impossible – him, begging for mercy?

75

Natalie

You should never, never have condemned him!

Elector

Begging for mercy, him? For goodness sake,
What's been happening? Why all this crying?
Have you seen him? You can tell me. Have you?

Natalie

In my Aunt's bedroom. It was horrible.
I'm a woman, and I'm afraid even
Of a snake that I've nearly trodden on;
But if Death came to me like a lion
Roaring, he would never find me so crushed,
So lost, so utterly unlike myself.
– Ah, is that what men come to? What men are?

Elector

There's no cause for despair, Daughter. He's free.

Natalie

He's what?

Elector

 Pardoned. I'll issue the reprieve
At once.

Natalie

 Do you mean that?

Elector

 I've just said it.

Natalie

He'll be reprieved? He's not going to die?

Elector

On my honour. I promise! How can I
Pit my judgement against such a hero's?
I hold him and his opinions, as you
Know, in the highest possible regard:
If he can show the verdict was unjust,
I will quash the sentence; and he is free!
 (He brings her a chair.)
Would you like to sit down for a moment?

(He goes to the desk, sits down and writes. Pause.)

Natalie

Why do I feel my heart is in my mouth?

Elector

(While he is writing.)

Is the Prince still up here in the Castle?

Natalie

No – he went back to his cell straightaway –

Elector

(Finishing and sealing the letter and bringing it to her.)

So, my little niece was really crying!
Do you want to deliver this yourself?

Natalie

To the prison? Why me?

Elector

(Putting the papers in her hand.) Why not? – Hello!

(A lackey enters.)

Have the carriage brought around. The Princess
Has an appointment with Colonel Homburg.

(The lackey leaves.)

He can thank you for his life in person.

(He embraces her.)

Natalie... Have you forgiven me now?

Natalie

(After a pause.)

What's moved you to clemency so quickly,
I've no idea, and shan't presume to ask.
But I do know that what I feel inside,
You would never make a mockery of:
This letter, whatever you've put in it,
Will be his salvation, I'm sure. Thank you.

Elector

Of course it will be; of course. As surely
As the Prince himself desires to be saved.

(Exit.)

Scene 2

Enter Count REUSS.

Natalie

Are you sure it can't wait until morning?

Reuss

(Handing her a paper.)
From Colonel Kottwitz, your Royal Highness.

Natalie

Yes. What does he want? *(She opens it.)*

Reuss

It's a petition.

Natalie

'…Most respectfully tendered, Madam…
The Princess' of Orange Own Cavalry.'
(Pause.)
Whose handwriting is this document in?

Reuss

Kottwitz wrote it himself – and signed it first.

Natalie

And these thirty other signatures, they're –

Reuss

The names of the officers, your Highness,
All of them, listed according to rank.

Natalie

And this petition has been sent to me?

Reuss

They humbly enquire whether you, ma'am, might,
As Colonel in Chief, add your signature
In the empty place left at the top there.
(Pause.)

Natalie

My cousin the Prince is, I hear, about
To be pardoned, at his Majesty's request;
So such a gesture would be redundant.

Reuss

Really?

Natalie

Nevertheless, this document,
Correctly used, might tip the scales his way –
Might even assist the Roy'l decision;
It seems churlish of me not to sign it.

(*She goes to sign it.*)

Reuss

We're deeply grateful, ma'am, for your support.

(*Pause.*)

Natalie

(*Turning to him again.*)
Only my regiment have signed, Count Reuss.

Reuss

Kottwitz is still stationed up in Arnstein,
While most of the regiments are down here;
It's not as if the Colonel was able
To circulate the petition freely.

Natalie

Nevertheless, it seems rather lightweight –
Are you quite sure, Count, that if you went down
Into the town, and spoke to some people,
You couldn't add some more names to your list?

Reuss

I think I could add the entire Army.

(*Pause.*)

Natalie

Then why don't you send out some officers?

Reuss

I'm afraid – I'd need the Colonel's orders
For that; he was keen that nothing be done
That could conceivably be misconstrued.

Natalie

He's a clever man. Bold, but hesitant;
As luck would have it, I've just remembered
The Elector passed onto me the task –
He's rather preoccupied at present –
Of issuing orders for his recall;
– There's a shortage of stabling in Arnstein.
I'll just sit down and write them now, shall I?
(She sits and writes.)

Reuss

That would be a very good idea, ma'am.

Natalie

Make the best use of this you can, Count Reuss.
(Folding and sealing the letter, she stands up.)
Of course, you understand, these papers must
Stay in your wallet; I don't want you to
Ride to Arnstein or give them to Kottwitz
Until I person'lly instruct you to.

Staff

(Entering.) The coach that was ordered is ready, ma'am.

Natalie

Have it brought round. I'll be there presently.
(Pause. She goes to the table and puts on her gloves.)
I'm going to visit Prince Homburg, Count;
Would you care to accompany me?
I'm sure there's room enough in the carriage.

Reuss

Madam, I'd be –

Natalie

Perhaps when I've seen him,
Our course of action will become clearer.
(Exeunt.)

Scene 3

The PRINCE stretches himself out on the ground.

Homburg

This Life is, says the poet, a journey,
And a short one. Really! From six feet up
Above the earth, down to six feet under.
I want to just stay here, right here, halfway.
Today your shoulders hold your head up high;
Already by tonight they start to stoop;
And come tomorrow, this is underfoot.
True, up there the sun, they say, shines as bright,
And over fairer fields than we have here,
I'm sure; a pity, then, these eyes must rot
Before they see such miraculous sights.

Scene 4

NATALIE enters, followed by REUSS and a PAGE.

Page

Her Highness the Princess of Orange.

Homburg

(*Standing.*) Natalie!

Natalie

Could you give us a moment alone, Count.

(*REUSS and the PAGE leave.*)

Homburg

Madam.

Natalie

Cousin.

Homburg

So, what is your news? Speak! How'm I doing?

Natalie

Well. Very well. As I said you would be,
You are pardoned; free; here is the letter.
It's all in there, complete with signature.

Homburg

That's not possible. No. This is a dream.

Natalie

Read it, read the letter. And then you'll see.

Homburg

'My dear Homburg, in imprisoning you
For your all-too-impetuous attack
I thought to do no more than my duty;
I also rather thought you would approve.
If you think an injustice has been done,
Then please, just tell me how – two words will do;
Your sword will be restored to you at once.'

(*Pause. The PRINCE looks at her.*)

Natalie

There, you see! Two brief words are all it takes –
Here, use this, use this pen; take it, and write!

Homburg

And this is his signature?

Natalie

F, Friedrich –

Homburg

He says that if I think –

Natalie

Of course he does!
Come on! Sit down! I'll dictate it for you.

(*She gets him in the chair.*)

Homburg

– I'd like to look through the letter once more.

Natalie

(*Tearing the letter from his hand.*)
What for? You did see your tomb in the church,
Mouth wide open, eager to get you in – ?
We haven't got much time. Sit down and write!

Homburg

The way you're carrying on, one would think
The lion's jaws were right here round my neck.

(He sits down, and takes the pen.)

Natalie

(Turning away.)

Write, or do you want to see me angry.

(The PRINCE rings, and Staff enters.)

Homburg

Some paper please, and my seal and some wax.

(The Staff brings them, and then retires again. The PRINCE writes. Pause. He tears up the letter and throws it under the table.)

Stupid way to start...

(He gets more paper.)

Natalie

(Picking up the letter.) Why? What have you put?
But this is fine – I think that's marvellous –

Homburg

Pah!
A scurvy turn of phrase, not a Princely.
I'm sure I can put it better than that...

(Pause. He reaches for the ELECTOR's letter, which is in NATALIE's hand.)

What does he actually say in that note?

Natalie

Nothing, nothing at all.

Homburg

Give it to me.

Natalie

You've already read –

Homburg

(Grabbing it.) So what if I have?
I just want to check I've got the right tone...

(He unfolds it and looks over it.)

Natalie

(*To herself.*) Our Father, which art in Heaven, help him.

Homburg

Look at this! It's really a masterpiece.
– You must have overlooked this bit…

Natalie

Which bit?

Homburg

The bit where he says the decision's mine.

Natalie

But it is!

Homburg

How right of him, how proper!
How befitting such a great-hearted man!

Natalie

Oh, his magnanimity is boundless;
– And now it is your turn to show yours; write
What he wants to read; you know they're just words;
But soon as those two words are in his hands,
This whole quarrel is instantly over.

Homburg

(*Putting the letter down.*)
No, my dear.
I'll think about it overnight.

Natalie

You are incomprehensible! Think what – ?
What for? Why wait?

Homburg

(*Rising from the chair.*) Please, don't ask me questions!
You haven't thought out what this letter means.
I cannot write, as I am required to,
That he's done me wrong; if you force me to
Write to him, the way I feel, feel tonight,
My God, I'll tell him: you've done me just right!
(*He sits down again and looks at the letter.*)

Natalie

You're insane. (*She bends over him.*)
 You don't know what you're saying.

Homburg

(*Pressing her hand.*) Just wait a minute! I must find...

Natalie

 Find what?

Homburg

The right words to use... I've almost got them.

Natalie

Homburg!

Homburg

(*Putting the pen down.*)
I'm list'ning. What?

Natalie

 Oh, my sweet friend!
I know, and I respect, what you're feeling.
But you listen to me; the firing squad
Chosen to gun you down in the morning
And then fire the salute over your grave
Have got their orders, and they will do it.
And if your conscience means that you cannot
Either accept this sentence or escape it
By meeting the demands of this letter,
Then I assure you, stalemate has been reached,
And he, conscience stricken no doubt, will have
That sentence carried out on you first thing.

Homburg

(*Writing.*) Ah well.

Natalie

Ah well?

Homburg

 He must do what he must;
I'm only obliged to do what is right.

Natalie

You make my skin crawl... Is that what you've put...?

Homburg

(*Finishing writing.*)
Homburg; given at Fehrbellin, the twelfth.
There, I'm all done. Franz!

(*He puts it in an envelope and seals it; a servant enters.*)

Natalie

Dear God in Heaven!

Homburg

(*Standing.*) Deliver this to my Lord and Master.

(*The servant leaves.*)

I will not grovel before a judge who
Stands so upright when passing his judgement.
I'm guilty, badly guilty, I know that, –
I readily admit it; but if he can't
Forgive me, unless I argue my case,
Well, then I want no part of his mercy.

(*NATALIE kisses him.*)

Natalie

If the twelve shots were to hit you right now
And take you down, I couldn't stop myself,
I would laugh and cry and shout out: Bravo!
– You must obey your heart. And meanwhile I
Must also be allowed to follow mine.
– Count Reuss!

(*The servant opens the door and Count REUSS enters.*)

Reuss

Madam!

Natalie

Go, with your letter,
To Arnstein, to General von Kottwitz.
The regiment is to march – Royal orders.
And I expect them here before midnight.

ACT FIVE

Scene 1

A state room in the Castle.

The ELECTOR enters half-dressed; TRUCHSS, von der GOLZ,
HOHENZOLLERN. Pages with lights.

Elector

Kottwitz? With her Royal Highness' Dragoons?
Here in the town?

Truchss

 Yes, your Royal Highness.
He's got them drawn up outside the Palace.

Elector

And? Solve the riddle for me, gentlemen;
Who summoned him here?

Hohenzollern

 That I don't know, sir.

Elector

He's stationed – I stationed him – in Arnstein.
Quickly! Go and get him and bring him here!

Golz

He will be reporting here shortly, sir.

Elector

Where is he now?

Golz

 Attending a meeting,
Apparently, of your milit'ry staff.

Elector

What sort of meeting?

Hohenzollern

 That I don't know, sir.

Truchss

Would your Royal Highness object to our
Joining him there for a few brief moments?

Elector

Where?

Truchss

At the aforementioned gathering.

Elector

(*After a short pause.*)

You are all dismissed.

Golz

Well, then, gentlemen –

(*They leave.*)

Scene 2

Elector

Strange. Now, if I were the Dey of Tunis,
I would, faced with this, sound the alarm.
I'd erect palisades, have the gates barred,
Bring up the cannon and howitzers.
But as it is Hans Kottwitz from Priegnitz,
Unauthorised, uninvited, I face,
I will deal with this in Prussian fashion.
Of the three silvery locks that survive
On his aged pate I shall seize just one
And by it lead him and his twelve squadrons
Quietly back to Arnstein and their tents.
No need to wake the town up while it sleeps.

(*He returns to his desk and rings; a SERVANT enters.*)

Run down for me and see what's going on –
Pretend it's you that wants to know.

Servant

Yes, sir.

Elector

And bring me in my clothes before you go.

(He brings them; the ELECTOR dresses and puts on his regalia of office.)

Scene 3

DÖRFLING enters.

Dörfling

Mutiny, your Highness.

Elector

(Still getting dressed.)
Calm down, calm down!
I really don't like – as you ought to know –
People ent'ring unannounced. What d'you want?

Dörfling

Sir, events of – I do apologise –
Considerable import bring me here.
Colonel Kottwitz – no authorisation –
Is here in town; a hundred officers
And now supporting him in his action;
A document's being circulated
That seeks to challenge your authority.

Elector

I already know all that. I expect
It's a plea for clemency for the Prince.

Dörfling

It is.

Elector

Well, I can see their point of view.

Dörfling

Word is that they intend, the idiots,
To hand the petition in here today,
And, in the event that you're unmoved, and
Uphold the sentence – how can I put this –
To get him out of jail using the troops.

Elector

Who's your informer on this?

Dörfling

My source was
Countess Retzow, she's quite reliable.

Elector

I think that when I hear it from a man,
I'll be worried. One sight of me down there
Would soon frighten off these would-be heroes.

Dörfling

Sir, I would ask you, if your intention
Is, eventually, to pardon the Prince:
Do it, before something dreadful happens.
Ev'ry Army – you know – loves a hero;
Don't let a commonplace spark of dissent
Be fanned into a real conflagration.
Neither Kottwitz nor the rabble round him
Know that I've spoken to you privately;
Send the Prince his sword, before they get here –
Send it back, surely he's earnt it by now:
Give the papers some good news for a change,
One less outrage for them all to report.

Elector

I'd need the Prince's permission for that,
Since he wasn't imprisoned on a whim,
And so can't be released on one either.
When the gentlemen arrive, I'll see them.

Dörfling

(*Aside.*) Damn him! Completely impenetrable.

Scene 4

A LACKEY enters with a letter.

Lackey

Colonels Kottwitz, Hennings, Truchss, and the rest
Request an audience.

(*The ELECTOR takes the letter from him.*)

Elector

Is this from Homburg?

Lackey

Yes, your Majesty.

Elector

Who gave it to you?

Lackey

One of the Swiss Guards posted at the gates,
Who had it from the Prince's adjutant.

(*The ELECTOR takes it to the desk and reads, then.*)

Elector

Bring me the death warrant, would you. Also,
I need a pass for Count Gustav von Horn,
The Swedish Ambassador. And bring in
Kottwitz and his crew.

(*The LACKEY exits.*)

Scene 5

*Enter KOTTWITZ, TRUCHSS, HOHENZOLLERN, von
SPARREN, REUSS, von der GOLZ, STRANZ, von MÖRNER.*

Kottwitz

(*With the petition.*)
Your Royal Majesty,
Allow me, on behalf of the Army,
To humbly present you with this paper.

Elector

Kottwitz, just before I take it, tell me,
Who was it ordered your march here to town?
I thought I had you stationed at Arnstein?

Kottwitz

Sir! The orders I received came from you.

Elector

Really? May I see those orders?

Kottwitz

Yes, sir.

Elector

(*Reading.*) 'Natalie, given here at Fehrbellin,
On behalf of my Uncle, Frederick.'

Kottwitz

I trust your Majesty was made aware
Of these orders?

Elector

Of course. What I meant was,
Who actually handed you the orders?

Kottwitz

Count Reuss.

Elector

(*After a momentary pause.*)
Well, your arrival's opportune! –
Colonel Homburg has been sentenced to death,
And you and your squadrons have been chosen
To do the honours first thing tomorrow.

Kottwitz

What, your Majesty?

Elector

(*Giving him the orders back.*)
Is the Regiment
Still stuck out the front in this dreadful fog?

Kottwitz

Fog, sir, I'm sorry –

Elector

Bring them into town.

Kottwitz

I already have sir; my orders were
That is where they were to be billeted.

Elector

Really? But two minutes ago – I thought –
You found your men quarters very quickly –
Good, that's all sorted out then! Well, welcome!
So, what brings you here? Do you bring news?

Kottwitz

This petition from your loyal army,
Sir.

Elector

 Give.

Kottwitz

 But your most recent pronouncement
Has dashed any hopes that I had of it.

Elector

I can resurrect them with my next one.
'Petition, entreating clemency for
Our commander, the wrongly accused
General Prince Friedrich von Hessen-Homburg.'
A noble name, gentlemen. And one not
Unworthy of such widely spread support.
 (*Looking at it again.*)
This paper was drafted by whom – ?

Kottwitz

 By me.

Elector

Is the Prince unaware of its contents?

Kottwitz

Completely unaware! It was discussed
And circulated just between ourselves.

Elector

Be patient with me for just a moment.
(*He goes to the desk and looks through the petition. A long pause.*)
Hm! Remarkable! – so you, old soldier,
Defend the Prince's action. You support
His attacking Wrangel before ordered.

Kottwitz

Yes, your Royal Highness, that Kottwitz does.

Elector

You weren't of that opinion at the time.

Kottwitz

I judged the situation wrongly, sir.
I should have deferred to his Highness's
Superior military insight.
If he'd decided to wait for orders,
The Swedes would have regrouped in their trenches
And you'd never have got your victory.

Elector

That's your interpretation, anyway.
But you knew I'd already sent Colonel
Hennings, to take out the Swedish bridgehead
That was Wrangel's escape route to his rear;
If my orders hadn't been disobeyed,
Hennings would have made short work of his task;
The bridges, within two hours at the most,
Would have been burnt, the river-bank secured,
And Wrangel, stuck in a swampful of mud,
Would have been wiped out lock, stock and barrel.

Kottwitz

Only an amateur, and you're not one,
Dreams of snatching himself Victory's wreath;
You know, or knew, that She demands patience.
The dragon which has ravaged our Prussia
Has been beaten back, and well bloodied too;
What more did you hope to do in one day?
So what if it lies low and pants for breath
And takes a month or two to lick its wounds?
We've learnt the tricks we need to catch the beast,
And we're eager now to practise our skills;
Unleash us on Wrangel just one more time
And we'll show him how to finish a job
By driving him back across the Baltic
For ever! Rome wasn't built in a day.

Elector

What hope have we of ever building it,
You fool, if anyone who likes can seize
The reins of Authority from my hands?
Do you think Fate often hands out laurels

To the reckless, as she has done this time?
I don't want victories dropping in my lap
Courtesy of that slut, Luck; I want Law
To mother my kingdom; I want her to
Bear me a whole dynasty of triumphs.

Kottwitz

Sir, Law, real Law, of the highest kind,
Authority's actual substance, its heart,
Cannot be defined by the mere letter;
What does it matter how the rule-book says?
Enemies should be beaten so long as
They kneel to lay their flags beneath your feet?
Do you want to see your loyal army
Reduced to a mere charade, a blunt blade
On the gilt belt of a dress uniform?
What sort of narrow, earthbound mind wants
A regime like that? What sort of dismal,
Short-sighted policy would, because of
Just the one case where instinct was proved wrong,
Then waste ten opportunities where sheer
Rash guts alone could have won us the day!
Do you think I spill my blood on the field
For you for wages, or to win medals?
For God's sake, it's worth more to me than that!
What! The one thing I want, my one desire,
Is to entirely, unimpededly
Be at the service of your Royal will,
T'augment the fame and name of this great house!
That is the reward for which I will bleed!
Say you do punish the Prince with death for
His unauthorised vict'ry; and that I,
I, tomorrow morning, similarly
Unauthorised, happen to come across
A skirmish – while I'm out on the hills, say;
Well, what sort of wretch would I be, if I
Didn't do eagerly just what he did.
And if you then said, quoting the rule-book,
'That, Kottwitz, will cost you your head!' I'd reply:
'Yes I know that, Sir; here it is, take it:
When I swore my oath to defend the crown

Body and soul, the head was not exempt;
You take nothing that's not already yours.'

Elector

What an extr'ordin'ry old man you are...
I'm completely stumped! The speech was dazzling –
The rhetoric impeccable – and as
You know, on top of all that, I like you;
But, the case must be settled; I now call
An expert witness:

(*He rings a bell and a servant enters.*)

The Prince of Homburg;
Have him released from the jail and brought here.

(*The servant leaves.*)

I think you'll find that there's a man can teach
What Discipline and Obedience are;
At least, his note here has a diff'rent ring
To the schoolboy essay on the Freedom
Of Man that you've just parroted at me.

(*He sits down at the desk and reads it.*)

Kottwitz

Brought here? Have who | brought here?

Sparren

– The Prince? –

Truchss

No, he wouldn't –

(*The Officers confer.*)

Elector

And who's this second letter from?

Hohenzollern

From me,
Sir.

Elector

(*Reading.*)
'Proof that Elector Friedrich was him-
Self responsible for the Prince's – '

God, but you've got a nerve…
– So! You trace the root cause of his lapse
On the battlefield back to me, do you?

Hohenzollern
I do, Majesty; that Hohenzollern does!

Elector
Well, good Lord, fact is stranger than fiction!
The one tries to show that he's not guilty,
While the other tries to show that I am!
How do you intend to prove your statement?

Hohenzollern
You doubtless recall the night, Majesty,
When we found the Prince, fast asleep, quite lost
Under the trees of the Palace gardens.
He seemed to be dreaming of the next day's fight,
And had a wreath of laurel in his hand.
You, as if to probe the workings of his mind,
Took his laurels from him, then, smiling, wound
That chain, from around your neck, through the leaves;
Then handed the wreath and chain, intertwined,
To her Highness, the Princess Natalie.
At this amazing sight, the Prince stands up
– and he blushes; he aches to grasp at such
A prize, held out to him by such a hand –
But you, pulling the Princess back with you,
Snatch ev'rything away – a door yawns open –
The girl, the chain, the laurels, all vanish,
And he – is holding a glove in his hand,
Seized from – who? whose hand? who knows? – he doesn't –
Alone, at midnight, cradled in the dark.

Elector
What sort of glove?

Hohenzollern
 If you'd let me finish,
Sir. To you this was a joke; but to him
It was serious – as I soon found out;
Because when I creep back in the garden,

And wake him up, and he gathers his wits,
And it comes flooding back, he's overcome –
With joy. It was really very touching;
He describes the entire sequence to me
As if it were a dream, ev'ry detail,
The most vivid dream that he's ever had;
And he starts to really convince himself
That he's been given some sort of a sign:
And that ev'rything he's seen in the dream,
The girl, the laurels, your chain of office,
Are his for the taking in the morning.

Elector
Hmn. Very odd. And the glove –

Hohenzollern
 Ah, the glove.
Something he dreamt, that is now actual,
That is both real and impossible;
He stares and stares at it, eyes wide open –
Colour, white; shape, and style – it seems to be
A lady's glove; but since there hasn't been
Anybody from whom it could have come
In the garden that night – that thought's cut off
By my hurrying him to the briefing;
What can't be explained is best forgotten –
And he just tucks the glove in his jacket.

Elector
And? Then?

Hohenzollern
 Then, off he goes, with pencil poised,
To the briefing, ready to hang on the
Field Marshall's ev'ry word of strategy;
The Electress and the Princess are there.
Imagine the immense astonishment
That seizes him when the Princess can't find
The very glove that's tucked in his jacket.
Dörfling calls out his name – repeatedly –
'The Prince of Homburg.' 'Your orders, Marshall...'

He replies, trying to collect his thoughts;
But he's so...dumbfounded, you'd think the sky
Had just come crashing down around his head –
 (*He pauses.*)

Elector
And was it the Princess's glove?

Hohenzollern
 It was.

 (*Pause.*)

Hohenzollern
 (*Going on.*)
He turns to stone; and then stands there – life-size,
Pencil raised, just as if he was alive,
But with all sensation – gone, with the one,
Magic, stroke; and only late that morning,
When the guns start thundering at his men,
Did he suddenly come round and ask me:
Dear boy, yesterday, what did Dörfling say,
By way of instructions, do remind me.

Dörfling
I can corroborate that account, sir.
I remember, the Prince didn't hear one
Word of my orders; I've often seen him
Looking odd, but never quite that...absent.

Elector
So, if I understand you correctly,
Your argument's constructed thus; if I
Had not had the bad taste to meddle with
Our young dreamer's mind – he'd have stayed blameless;
Not been distracted during the briefing;
Not disobed'ent during the battle.
Yes? Yes? That's what you're saying?

Hohenzollern
 Majesty,
I leave you to complete the argument.

Elector

How imbecilic of you. If you'd not
Invited me out into the garden,
Then I'd never have had the occasion
To play my harmless joke on our dreamer.
Therefore, I'd argue, with some conviction,
That the root cause of his mistakes, was you!
Oh, the Delphic wisdom of uniform!

Hohenzollern

Thank you, your Majesty. I've made my point.

Scene 6

An OFFICER enters.

Officer

The Prince will be here in a moment, sir.

Elector

Good – have him come in.

Officer

 In a minute, sir;
When we were on the way over he asked
If we might unlock the churchyard briefly.

Elector

The churchyard?

Officer

 Yes.

Elector

 Why?

Officer

 I don't really know.
Someone said he wanted to see the vault
That you've ordered be opened up for him.

Elector

Quite possibly. When he's here, let me know.
 (*He goes to his desk and examines some papers.*)

Truchss

He's here.

Scene 7

The PRINCE enters, guarded.

Elector

My dear Prince, just the man! I need your help!
Colonel Kottwitz has brought me this paper,
A petition, on your behalf, look, with
At least a hundred signatures listed.
The Army, it says, demands your freedom,
And won't accept the court-martial's verdict –
Here, please, do feel free to read it yourself.

(*He gives him the paper.*)

Homburg

(*After giving it a look, he turns and looks round at the
circle of Officers.*)

Kottwitz, you're a good man; give me your hand.
You've done more for me than I ever did
For you, in battle. But now you must go
Quietly back to Arnstein where you came from,
And then stay put; I've given it some thought –
I want to die this death I'm sentenced to.

Kottwitz

No, never; never! Why do you say that?

Hohenzollern

He wants to die – !

Truchss

We won't let that happen!

Golz

Your Majesty, you must listen to us.

Homburg

Quiet! Nothing's going to change my mind!
I want to see the sacred rules of war,
Which I infringed in full view of the ranks,
Glorified by my voluntary death.
What is one paltry victory, comrades,

Like mine over Wrangel, compared to the
Triumph over that deadliest of our
Enemies, Insurrection, that will be
Celebrated here later this morning?
Let all our enemies, without, within,
Be overwhelmed, and all the people freed!
And you, Sir – whom I once used to address
By another name, now sadly forfeit –
Now you have me penitent at your feet!
Forgive me, if at the crucial moment
I tried too hard to please you, forgive me:
And let Death absolve me of all my guilt;
Let my heart, which is without rancour, which
Gladly bows to your edict, rest easy,
Knowing that you too feel no anger now;
And since this is our hour of farewell,
Grant a dying man his final request.

Elector
I give you my word as an Officer,
Whatever it is, I'll make it happen.

Homburg
Don't use your niece to buy a truce with the
Swedes. Send their negotiator packing;
Karl Gustav's proposal is an insult;
Write him your answer in a blast of lead.

Elector
(*Kissing his forehead.*)
Just as you say. She's Homburg's bride, I'll write.

Homburg
There now, you've made me feel alive again.
I'll ask the angels to rain down blessings
From their cloudy thrones, the ones they reserve
For the heads of all-conquering heroes:
Go back to your war, Sir, and Oh, may you
Win all of your battles: you deserve to.

Elector
Guard! Escort his Highness back to prison.

Scene 8

NATALIE and the ELECTRESS appear in the doorway.

Natalie

No, let me go! I don't care what they think!
The only thing I care about is him.
Oh, my poor unhappy | friend –

Homburg

(*Starting to leave.*) Take me away!

Truchss

No, no, sir, never –

> (*They bar his way.*)

Homburg

Please take me away!

Hohenzollern

Your Majesty, how can you | bear to –

Homburg

(*Tearing himself away.*) Do you want
To see me dragged out there in chains? Move!! All
I ever had to do with life is done.

> (*He goes, under guard.*)

Natalie

Oh, let me crawl into the earth with you!
What is the point of sunlight, after this?

Scene 9

Dörfling

God in heaven, did it have to come to this?

> (*The ELECTOR speaks privately and urgently with an
> Officer, who leaves.*)

Kottwitz

Sir, after…what has happened, I take it
We are dismissed?

Elector
No! Not quite yet you're not!
But as soon as you are, I'll let you know!

(*He looks at him pointedly for a moment; then he picks up the
papers that the member of his staff brought him and turns
with these to Field Marshall DÖRFLING.*)

This is Count von Horn of Sweden's passport;
I must grant the Prince's final request;
Hostilities will resume in three days.

(*Pause. He glances at the death warrant.*)

Well, it's up to you, gentlemen. The Prince,
With his insolence and disobed'ence,
Has cost me two good victories this year;
And he's badly spoilt a third for me, too.
Having learnt some lessons these past few days,
Are you prepared to trust him with a fourth?

Kottwitz
What? Your Royal Majes|ty –

Truchss
Your Majesty –

Elector
Well, are you? Are you?

Kottwitz
God is my witness,
You could be hanging over the Abyss,
And he wouldn't lift a single finger
To save you – unless given the order.

(*The ELECTOR tears the death sentence.*)

Elector
Come, gentlemen; back into the garden.

(*They all leave.*)

Scene 10

The Castle, with the ramp leading down into the garden – just as in the first scene. It is night once more.

The PRINCE is led blindfold by Captain STRANZ in through the lower garden gate. Guards. In the distance you can hear the drums of a funeral march.

Homburg

Oh, Immortality, now you are mine!
I can see a light, though my eyes are blind;
And it shines brighter than a thousand suns.
I can feel wings sprouting from my shoulders,
Feel myself rising into thin, calm air;
And like on a ship, when the wind takes it,
You see the harbour lights slipping away –
Ev'rything is sinking down to sunset:
I can still distinguish colours, and shapes,
And now, ev'rything below me…is mist.

(The PRINCE sits on the bench in the middle of the garden. Captain STRANZ leaves him and looks up to the ramp.)

Ah, don't violets smell lovely at night!
Can't you smell them?

Stranz

Those are carnations, sir.

Homburg

Carnations? Who planted them?

Stranz

No idea.
I think some girl or other must have done.
Would you like me to pick you one?

Homburg

Thank you.
I'll put them in water when I get home.

Scene 11

Up on the castle ramp the ELECTOR appears, holding the laurel wreath, with the gold chain wound round it, together with all those who were there in the first scene. HOHENZOLLERN waves to STRANZ with his handkerchief over the balustrade; he leaves the PRINCE and speaks to the Guards upstage.

Homburg

Tell me, why is the light getting stronger?

Stranz

(*Coming back to him.*)
Your Highness, you have to stand up straight now.

Homburg

What is it?

Stranz

There's no need to be frightened.
I just want to open your eyes again.

Homburg

Is this the very end then?

Stranz

Yes it is –
Congratulations – and you deserve them!

(The ELECTOR hands the wreath, with the chain hanging from it, to NATALIE, and leads her down the ramp. The court follows. NATALIE, surrounded by torches, approaches the PRINCE, who rises astounded; she crowns him with the wreath, hangs the chain about his neck, and presses his hand to her heart. He falls unconscious.)

Natalie

Oh, God! – so happy, he could die!

Hohenzollern

(*Catching him.*) Help me!

Elector

Fire all the cannon – that'll bring him round.

(*Cannon thunder. A march. The Castle blazes into light.*)

Kottwitz

Huzza! Huzza, the Prince of Homburg!

Officers

Huzza! Huzza! Huzza! Huzza! Huzza!

(*A moment of silence.*)

Homburg

Tell me, is this a dream?

Kottwitz

A dream? Of course.

Officer

Present Arms!

Truchss

Quick March!

Dörfling

To Victory, Sir!!

All

Dust. Down into dust with our enemies.

The End.